Point Taken

Brilliant Business Advice from Women at the Top

Jenny Remington

Sulit Press

Paperback: 979-8-9880332-9-5

Ebook: 979-8-9905753-0-1

Edited by Kristi Koeter and Michelle Savage

Cover art by Elizabeth Hauser and Christy Jaynes

Sulit Press

www.sulitpress.com

Ready to fast-track your publishing career, increase your visibility, or boost your business?

Harness the power of partnership by contributing a 3,000-word chapter to one of our upcoming Multi-Author Books!

If you are...

- Inspired by what you do and want to generously share what you've learned...

- Committed to meeting deadlines and doing your best work...

- Ready to connect with other aspiring authors who are as excited as you are to share your book with the world...

Then our multi-author books might be the right path for you!

Learn more at https://www.sulitpress.com/

Contents

Introduction

Whether you're an aspiring entrepreneur or an executive, rising to the top as a woman requires agility, resiliency, and fortitude. Growth is rarely linear, and while you learn through your own experiences, that takes something you only have in limited quantities, which is *time*!

But what if you could tap into the wisdom of top-tier female executives, company founders, and high-vibe go-getters to learn which tactical strategies, resources, and mindset shifts have made the biggest impact on their business?

Point Taken isn't just a collection of anecdotes; it's a roadmap for professional metamorphosis. As you turn the pages, you'll find yourself immersed in narratives of hard-earned lessons and game-changing approaches. You'll learn that the path to success is often paved with bold moves, unexpected turns, and the courage to venture beyond your comfort zone.

Whether you're inspired to master new skills, seek out a mentor, make better decisions faster, lead with confidence, or communicate more effectively, these essays will help you step into your own authority and own it!

Learning from women who have made it to where you want to be can shed light along the path and inject your perspective with fresh insight and encouragement. So, dive in with an open mind to discover *Brilliant Business Advice* from women leaders across a broad range of industries. Whether you're inspired by their wins or their wisdom, you're certain to discover some points worth taking.

P raise for *Point Taken: Brilliant Business Advice from Women at the Top*

"From the moment I opened this book, I screamed YES! The various essays are bold, courageous, and honest and left my heart more open and tender than when I started. This book is for every woman careening through work and life just trying to make it out alive with the very clear message: happiness, joy and freedom reside in the necessary surrenders to thrive and serve from our Highest Selves. Thank you for this book!"

— Jenny Davidson-Goldbronn, facilitator, executive coach, fundraiser

"Each story in Point Taken displays masterful talent with words, draws you in and sets you free by dispelling any myths that were taught to us that no longer serve us. The life experiences shared remind me that rest is necessary for the mind, body and soul and through rest much can be achieved. Thank you to all the woman for your strength and ability to share and teach simultaneously."

—Atoya Burleson, Co-Host of Inside Lines Podcast

"Point Taken contains compelling narratives that pull you in immediately. I kept recognizing situations I had been in myself, with an 'Ah ha' moment each time I read a storyline I felt like I'd been a character in. You can read this book for sound advice and situational leadership nuggets that you can put into practice right away."

— Anne Gentle

"Every single chapter held my complete attention because they were full of experiences I could relate to and even put myself in the room or moment. I enjoyed learning how each author used those experiences to pivot - a very practical and beneficial read."

— Jenni Lanier

"In this book, these amazing, smart, and openly vulnerable women share not just their honest personal discovery journeys, but a road map to how we can all learn from ourselves if we are willing to not overthink every little thing, and to take a pause from our work lives to enjoy our one life.

Three chapters in and I was already reshaping my world to accept and integrate the energy and lessons from the book. 'No' really is a complete sentence but saying 'yes' to yourself leads to happiness, healing and liberation."

— Eric Goodwin, CEO of Goodwin Sports Management

"A great read on finding your voice, holding boundaries, and what it takes to be a successful female leader. I enjoyed the heartfelt stories and the lessons learned from experiences in and out of work. Definitely worth a read and full of helpful advice and takeaways."

— Lindsay Ferrer

"This book is full of relatable stories about women in the complex spaces of work and life. As I read it, so much resonated with my own experiences, offering profound insights into the challenges and triumphs of navigating modern femininity in multifaceted roles. It's a compelling and empowering read that sheds light on the intricacies of the female experience."

— Elizabeth Lani

"What I love most about this book is that you can see yourself in the stories. While each of the writers clearly has her own journey, her own perspective and position in life, the 'key takeaway' from each one is absolutely relevant and applicable to my own life. This isn't easy to do! What a lovely, inspirational read. I look forward to revisiting these stories in those times when things feel murky."

— Peppur Chambers, author, writer, creator

"This book is not only brilliant business advice from women at the top, but a treasure trove of the realities of what it takes to build a business as a woman today. Inspiring with a dash of humor, some sadness but most of all, lessons to share for other women coming up behind. Thank you for this collection of brilliant women and their stories."

— Louise Brogan, LinkedIn consultant, trainer

"*Point Taken, Brilliant Business Advice from Women at the Top* is filled with empowering insights for women lead-

ers and entrepreneurs. Told through storytelling, it guides readers to make room for the things that matter, striking a balance for success and well-being. Through its wisdom, readers will find themselves inspired to navigate their journeys with resilience and authenticity."

— Stephanie Flores

"My first read of *Point Taken* nourished my outlook on the mindset that's necessary for true, fulfilling success. Each woman in this book has such an indelible story to share that everyone can benefit from. I found myself excited with each page turn, to learn more about what tools each woman used to carve out a pathway towards a harmonious and resilient career practice."

— Joel Steingold, actor, voiceover expert (The Chi on Showtime)

"*Point Taken* is a compelling and entertaining book about ordinary businesswomen overcoming the odds in extraordinary circumstances. They share their experiences with unique points of view and provide useful wisdom that will stay with you long after you turn the last page."

— Gary Hardwick, award-winning writer, director, author

"In a world where success is often devoid of the messy parts that are required for a real triumph to occur, I love how raw *Point Taken* is. I feel like I'm on a journey with these courageous women, and the vulnerability with which these stories are written inspires me to examine my own experiences and adjust accordingly. I think anyone reading this, especially aspiring women in corporate America will feel like they just accessed dozens of mentors who are speaking directly to them."

— Aaron Mitchell, entrepreneur, coach, advisor

1
From Boiled to Bold

Michele Lau Torres

*O*H MY GOD, I realized as I drove into work. *I am a boiled lobster!*

They say that if you put a lobster in a pot of boiling water, it will try to escape. But if you put it in a pot of cold water and slowly heat it up, it will stay there until it dies. And it probably does not realize that it is dying until BOOM! It wakes up DEAD.

The night before, I delved into a chapter of a leadership book that shook me to my core. I realized that I was unwittingly morphing into a toxic leader, not by choice, but

by the effects of a manipulative and hostile work environ-
ment. My boss was the boiling water, the catalyst that had
changed me without me knowing it. Slowly, insidiously,
she had altered my essence until I found myself far re-
moved from who I once was.

I weaved in and out of traffic getting nowhere fast. The
morning was bright—I had rolled down the window and
turned on some tunes in an attempt to block out the sober
realization that I had to reclaim my authentic self, my
value, and my peace of mind. How on earth did I get here?
Who had I become?

· · · · · ● · ● · · ·

My office was small and cozy with a sizable window that
fought for attention next to an oversized imposing cabinet.
The window overlooked greenery and playing squirrels,
which made up for the stark office lighting and cold gray
furniture. When you were not looking out at the pretty
trees, you were assaulted by my desk—a chaotic jumble of
papers strewn everywhere. Documents, ideas, proposals,
multicolored Post-its, and files covered every inch, reflect-
ing my perpetual state of messiness—a trait I struggled to
overcome.

But on this particular day, I made a concerted effort to rectify the disorder. I gathered all my papers into a towering stack, aiming to create the illusion of organization and tidiness. The reason for this sudden cleanliness? My new manager was starting today, someone I had encountered only once before. Her inspiring words on leadership during a conference years earlier left a lasting impression, fueling my excitement at the prospect of working alongside her.

On her inaugural day, she settled into her office, just around the corner from mine. Though our offices were separated by a mere hallway, we would exist in separate worlds, with only chance encounters on trips to meetings or the break room to bridge the divide. Although I was eager to make my introduction, I never had the chance on that first day. Surprisingly, no meeting occurred at all during the entire first week, which struck me as odd considering I was her direct report. *She's busy acclimatizing herself to a new company*, I told myself.

As days turned into weeks, the absence of a one-on-one meeting grew increasingly conspicuous. With a trove of strategies, updates, and challenges to discuss, I awaited the chance to connect with my new boss. It was budget time; Finance had been breathing down my neck, and

when the second week slipped by without a meeting, I decided to make the first move and extended a calendar invitation. She never responded to the invite. She did not accept it. She did not decline it. In fact, I am certain it is still hanging out somewhere in cyberspace. Shortly after my proposed one-on-one meeting with her, we gathered in a management staff meeting. There were seven of us who reported directly to her. These were my peers, and usually, we would be a spirited team with camaraderie and problem solving and fellowship. Today, the ambiance was sterile, veiled as though we were in a hospital waiting room ready for bad news. And it came, in the form of a new figure—Corine, the boss's enigmatic right-hand woman. Her sudden appearance was described as "assistance," leaving us all scrambling to decipher her role in the grand scheme of things.

Despite the uncertainty swirling around Corine, one thing was abundantly clear; she was going to hold considerable sway within the organization. As the second-in-command, her position spoke volumes, even though it was omitted from the organizational chart. While we were assured that we didn't report directly to Corine, we had to get her agreement on anything that would make its way to the boss.

Okaaaaaayyyyy I thought to myself.

As the meeting drew to a close, I approached my boss, "I sent you a calendar invite last week," I chirped, "I thought it would be useful for us to go over my portfolio. Are you available in the next few days?"

"Yes, I see that you are trying to get on my calendar," she responded, as her heels clicked away.

I had been dumped before we had even started dating!

My one-on-one meeting never happened.

In the weeks that followed, my hopes for a meaningful connection evaporated. About a month had passed when I discovered that she was meeting with my team to get the information she needed, taking them out to lunch, and introducing herself.

I was flabbergasted. What did I not know?

Under my new boss and a revamped structure, the organization took on a new guise—a waiting game of uncertainties about the future with no clear end in sight. It became increasingly evident that something was amiss.

As the months passed, I found myself amid a sea of changes, including my waning influence.

I was being bypassed and sidelined in favor of clandestine meetings and covert decision-making. Frustration simmered beneath the surface as I watched my team receive direction and information from sources above me. My team, once loyal and unified, now seemed to slip through my fingers, as information flowed freely without my involvement.

I started to question the motives of my team. Not just my team, but also my peers. We had all begun to close our office doors, we rarely spoke to one another, and when we did, we found ourselves squabbling over resources with no real line of sight on what we were trying to achieve. What we all felt was our influence and autonomy slipping. The seeds of mistrust were sown. None of us knew what was going on or how decisions were being made. All of us believed the other was in the meetings and not being honest about it, and we all pretended we knew more than we really knew in an attempt to *save face*. The truth became elusive, and lies became the norm, leaving me questioning my role within the organization.

· · · · · ● · ● · · ·

"You are under investigation" he announced.

It was my boss's boss on the phone.

"Me? What for?" I stood up and closed my office door.

"It's not about you, Michele, but your telework practices," he explained.

"Telework practices? I have a laptop, VPN, and dual authentication for a reason," I countered, my confusion mounting. "In my role, I telework; it is expected. I have been doing this for years."

"I know, but we have to address some concerns," he responded cryptically.

"Concerns? From who?" I pressed, my mind racing.

"From your leadership," came the ominous reply.

And then it hit me like a ton of bricks. It was my own boss who'd raised the alarm. "I understand," I managed to choke out, trying to keep my voice steady. "Do I need to return my equipment?"

My stomach was churning. Under investigation—for the first time ever. I could feel the panic rise, the feeling of being watched, of being under the microscope. My neck and face felt hot. I needed to take a walk.

I gulped in the ninety-eight-degree air—not very comforting. It was hot and bright, and humid. I put on my sunglasses and stood for a moment as I felt the first sting of tears. I wanted to go home and put a nice soft blanket over my head with the AC on. I walked to my car—got in and started it up with the AC on full blast. Shock turned to anger. The squirrels ran across the asphalt chasing tails. I'd poured my heart and soul into this job, working late nights and weekends without complaint. And now, all that effort was being called into question.

Anger turned to fear.

I took my laptop and authenticator to my boss's office. Knocking on the door I heard a quiet "Yes?"

"I have been informed that I am under investigation for telework violations," I said, trying not to sound worried. "I thought I should return my laptop until further notice."

"No need," she returned. "I do not want it. Keep it in your possession."

"Okay. I plan to work in the office and only use my desktop until the investigation is concluded," I said.

"Yes, that would be best."

The conversation was cold and transactional. I couldn't shake the sense of uncertainty hanging over me. I drove home in silence that day wondering if I would be in my role for much longer. It was time to review my resume.

· · · · · ● · ● · · ·

I was surprised when the call came through. I was making dinner.

"I need you to send me information for my report," the voice on the other end was curt. "I thought I had until the end of the week, but the meeting has been moved, I need what you have."

"Of course, when do you need it?" I replied.

"Within the hour," came the brisk response. I could tell that she did not like having to call and ask me for assistance.

"All right, so I have your approval to telework?" I asked cautiously.

There was a pause on the line before the reply came, "Are you suggesting that you won't send me the report?"

"Not at all," I reassured, "I just want to ensure I'm following protocol. I've been advised against teleworking."

"Come see me in my office first thing tomorrow" was the terse instruction before the call ended.

My stomach started to tense as I thought of the conversation ahead of me. Suddenly I wasn't hungry anymore. I turned off the burners and decided that it was a cereal for dinner day and logged in to send off the requested information.

As I entered her office, the atmosphere felt tense. She sat rigidly behind her desk, her hands resting firmly on its surface. I bade her "good morning," but the exchange did little to mask the tension.

"I want you to know that you were insubordinate yesterday," she declared with an icy glare. When she spoke, her lips barely moved. "And I do not appreciate how you spoke to me when I had a reasonable request. I plan to make a note of this and issue you a warning."

Frustration and anger welled up inside me. "Insubordinate?" I echoed. I was surprised by the tone of my own voice, despite the anxiety and disbelief churning inside me. "What exactly was insubordinate about my actions?" I continued evenly. "I sent you the information as requested. I don't see how asking for clarity constitutes insubor-

dination. I would like a definitive answer on whether I can telework or not."

"You may telework," she snapped. "The investigation came back clear."

"Thank you for letting me know," I said looking her in the eye. With the threat of a reprimand looming, I felt fear—what else would be coming my way? *I need to leave.*

· · · · ● · · · ·

It was a phone interview. I had stayed home to take it, and about fifteen minutes before the scheduled interview, I began to bleed. Panicking, I found myself stumbling over my words, unable to focus on the questions being asked. One of the interviewers seemed impatient, she had clearly had enough of my rambling, and interrupted my answer with an aggressively delivered clarifying question, adding to my already mounting stress. *When will this brutal call end?* I was so relieved to hang up after what seemed to be the longest interview in the world.

As I checked myself in the bathroom my heart began to race—something was seriously wrong.

"I'm bleeding!" I blurted out to the nurse who I had called. "It's a lot."

"Don't panic," she said. "Come in."

Tears ran down my face uncontrollably as they took me to a quiet office away from all the waiting pregnant women and newborn babies. The sonogram confirmed the miscarriage. No heartbeat could be found at eleven weeks.

Devastated and numb, I went home, sat on the sofa, and sobbed. All my excitement for the future had come to an abrupt end. The sense of loss was overwhelming, only to be overtaken by guilt. The weight of it was crushing. This was my fault. I take on too much, I work too much, I don't slow down, I'm stressed all the time, I shouldn't have been wearing heels. Did I forget to take my prenatal pills?

My cell phone rang, shattering sobs and silence. It was my boss, requesting presentation slides for a report we were collaborating on.

"In fact," she announced, "Come into the office, that would help, I would like you to review the data and presentation with me."

"I am not feeling great today," I said, trying to keep my voice steady. "I need to take off the rest of today and to-

morrow if that's okay." A heavy silence filled the space at the weight of my request. "I will send you the latest data now. Can I review it with you the day after tomorrow?" I ventured.

"You were fine this morning," came her response, devoid of any warmth and laced with disbelief. She clearly doubted my sincerity and the accusation stung.

She thinks I'm lying.

"Yes. I know," I conceded.

"And now you are sick?" She responded skeptically.

"I need a day or so, yes." I could feel my voice cracking, as emotion threatened to overwhelm me.

"This is a very important report, Michele." She emphasized, her tone stern.

"I know, and I am sorry." The tears were coming again. I could feel them taking over my breathing. I took a deep breath and began as my lips quivered. "Ma'am, I had a miscarriage this morning, and I need some time to recover." I could hear the sorrow in my voice as I struggled to maintain composure. I didn't want to tell her this. I didn't want her to hear me like this either.

"I see. I didn't know you were pregnant." Her response softened slightly.

"No one knew."

"Okay, I'll see you the day after tomorrow."

Hanging up the phone, I broke into tears again. This was my fault.

· · · ● · ● · ● · · ·

"You can't hire her. It's a bad investment," she declared, her voice sharp and resolute. "No sooner will she understand her role and job, and she will be on long-term leave." I stepped into her office and gently closed the door.

"What you just said is against the law," I countered firmly. "Being pregnant does not preclude her from being hired." A surge of indignation swept over me as I thought for a second of my own recent miscarriage and I wondered for a horrified moment what her response would have been if I had revealed my pregnancy to her. Was she actually glad I had lost my pregnancy as it would have been inconvenient for the company? Did she think I was being emotional with regard to this hire and it was clouding my judgment?

A flicker of annoyance crossed her face. "Are you saying you're going to hire her against my direct order?" she demanded.

"I am asking you not to repeat what you just said to me to anyone else. The candidate is in the hiring and testing process, and I do not intend to remove her."

Her lips pressed into a tight thin line. "So you're telling me you are going to hire her?"

"I am saying that she will continue through the process, and if she is the top candidate, we will make an offer."

"If you hire her, you are being directly insubordinate," she warned.

There was that word again. The second time in as many months.

"I am protecting you and this company," I responded with confidence. "What you are telling me to do is illegal."

Feeling the need to protect myself, I rang the company lawyer, Katie.

Katie answered the call with her usual bright sing-song voice. She had a penchant for gypsy skirts when she wasn't in court, and despite her incredibly sharp legal mind, I

loved her carefree persona, even when she listened intently.

I felt bad that I subdued her sunny disposition as I told her what my boss had said.

"I need you to make this go away, Katie," I pleaded. "If I am disciplined for insubordination, I will be reporting the exact nature of the order."

I don't know what Katie did or said, but I had peace for a little while. As the hiring process came to a close, the top candidate was the pregnant woman; I hired her and not a word was spoken to me about it.

Everything seemed to reach a boiling point after an unusual management meeting called on a Friday afternoon. Meetings on a Friday were rare, especially in the absence of Corine, who was away at a conference. It was highly unusual for the boss to convene the entire management team without her usual backup.

"I have some disturbing information," she began stony-faced.

A document was leaked to a competitor. And the culprit, who she ascertained had *broken the law,* was in that very room. We all looked at one another. There was no breach

of contract here, there were no confidentiality agreements signed, and the document held no trade secrets; it was a company needs analysis report, with no financial data attached.

Seriously? Why would any of us leak anything?

Then she made her announcement: each of us was to undergo a polygraph test to uncover the truth.

This was it. The straw. Nothing screams "trust" like strapping your colleagues to a lie detector.

I was beyond outraged. I knew what she was doing, beating the bush to see what came out. It was a bullying and controlling tactic, and I had had enough.

"No ma'am," I said. "If you insist on administering a polygraph, I'll need to consult with my legal counsel."

"Hook me up! I have nothing to hide," exclaimed my colleague, with a bravado that failed to mask the tension in the room.

As the meeting subsided, one thing was clear: My boss had unquestionably eroded the trust that her team had established before her arrival. She was beyond toxic. After

the weekend, I called her and asked her to meet me for a coffee.

The café smelled of fresh ground coffee beans and sugar. The wooden floors and tables gave off a warm vibe juxtapositioned with the expansive windows throwing light into all the corners of the space.

I could see that she was uncomfortable. I was too. Unsure of how to broach the conversation, I opted for a cautious approach. "How do you think the meeting went on Friday?" I enquired.

"I think it could have gone better," she responded, her discomfort palpable. "I also think you leaked the document." Her accusation did not catch me off guard; rather, it confirmed my suspicions.

"I figured as much," I returned unsurprised. *Was it just me or did it suddenly get uncomfortably warm?*

"Did it ever occur to you to ask me if I leaked it? Because I didn't." I suddenly felt very tired. I had been in what seemed like a constant state of fear since she became my boss, and I was finally being real. "And if you had taken the time to really get to know me this past year, you would know that I don't operate that way."

She scrutinized me intently. "You were very combative in the meeting," she said.

"I do not do well with threats.," I responded.

She didn't take her eyes off me. Did she even know or care that at this very moment, I was potentially throwing my career to the wind? I had no idea how she was going to respond, but I couldn't take it anymore—the lies, the uncertainty, the constant feeling of dread and fear. I was miserable.

I needed to express the toll her leadership had taken on me—the atmosphere of mistrust, the uncertainty, the ever-present dread. And as the café began to fill up with lunchtime patrons, so did my courage. She had to know that I could not get behind her style of leadership and that I believed she was harming the organization. I recounted instances where she had misled me directly, highlighting the erosion of trust that had gradually consumed our professional relationship. And then, I broached the topic of my departure, proposing an exit strategy that would allow me to depart the company with grace. My only ask was for her cooperation in facilitating my departure and providing a fair reference so we could both move on from our current situation.

She said no.

She said she needed me.

She said she would be gone in less than six months. An interesting revelation, but not soon enough.

I left the café utterly deflated, and yet in the months to follow, there was a notable shift in our interactions. I think she respected my honesty in some way or another because after our conversation in the café, she let me and my team work without much interference.

To my shame, the damage to my team was already done.

My team was falling apart. As they were being used as pawns in a larger context, my trust in them was diminishing. Over the months I had pulled a couple of team members aside and shared my concerns, my worries, the horrible things that were going on in the organization, and the bad decisions the boss was making—I shed all professional filters. I needed allies. I am not proud of spreading fear among my team. I began to create an "in group" and an "out group."

"Be careful," I would say to the "in group." "Watch your back. Don't trust the boss or Corine; they are looking for

ways to eliminate your influence. Make sure you keep me informed."

I had them scared. "I will protect you," I told them. "I will fight for you," I assured them. And I meant it. I loved my team, I didn't want to see their work dismantled, and I didn't want their reputation to be damaged or their value in the organization questioned. Looking back, I see how misled I was.

• • • • • • • • •

As I perused the leadership section of Barnes and Noble, the muted sound of rustling pages and the familiar scent of paper, intermingled with the subtle fragrance of candles on display nearby, gave me a sense of contentment. I could stay in a bookstore all day long, but today I was on a mission. I had been asked to give a keynote on a book I hadn't read—*Leadership and Self-Deception* by the Arbinger Institute. I accepted the request and had a week to read the book and write the keynote.

Lying in bed worn out after a day at work, I overthrew my reluctance and opened the book. I was scanning it when a chapter jumped out at me. It was a story of a man named Bud, who had a baby son who was crying in the middle of

the night, and although he wanted to get up and be a good husband to help his exhausted wife, he too was tired and did not get out of bed to care for his son. As his wife was slow to wake, Bud told himself a story; that his wife was lazy, that she was *expecting* him to tend to their son, that he was a good dad and worked hard, and that she was being selfish.

Bud was "in the box" of self-deception, through self-betrayal. Self-betrayal is when you do not do what you know you should do, and blame others to justify your actions. It is when you cannot see that you yourself are a problem.

Reading the chapter was like a snap into reality. *Oh my GOD*, I said out loud. *I am the problem*. I have become poisonous. I am not protecting my team; *I am damaging it*. I am inserting fear and uncertainty. I am not providing protection; *I am cascading toxicity*. I am not thinking about *them* and what *they need*; I am thinking about *me* and my *ego*. They do not deserve this version of me, and I am better than this version of me.

I own me. I own who I am, and I get to choose who I want to be and the kind of leader I am. I gave my power away. I could not control the actions of my toxic leader, but I *could* control MY actions. I may be a victim to toxic

leadership, but that does not give me an excuse to behave badly or outside of my character or beliefs.

Realizing how I was contributing to toxic leadership dynamics, I embarked on a thorough examination of how I reached that point. How did it all happen? How did I let one toxic leader change me so much? I identified five strategies she used that were so impactful and reflected on how my own leadership changed from forthright to fearful.

1. Truth/Lies—creating an environment in which gaslighting was allowed.

2. Divide and Rule—siloing direct reports and not sharing information.

3. Fear—taking away autonomy, and using policies and threats as a form of control.

4. Oppression—reducing resources, dismantling projects, and creating barriers to innovation.

5. Trust—ensuring that mistrust prevails to prevent a unified voice.

It was time for the boiled lobster to be reincarnated! It was time to reclaim my personal power and to lead with

optimism and love, not with fear. It was time to remember who I was and who I wanted to be. It was time to lead with courage and transparency.

The first step I took was to apologize to my team and share my vulnerability, fears, and missteps with them. We cried.

I now understand that leadership is a mindset. When you shift your perspective and set a new course, your actions naturally align with that change. I gave up smoking over twenty years ago. After countless failed attempts and empty promises to quit, I reached a turning point. The day I gave up cigarettes, I just *did* it. I made the decision half way through a cigarette, put it out, and said to myself *I no longer smoke.* It took friends and family a much longer time to realize that I was a non-smoker. They were used to me *saying* over the years that I was going to stop smoking; it was the change in my behaviors that made them finally believe.

When you believe something, you behave in tandem with that belief, and transformation can occur quite quickly. Rebuilding one's brand is a tougher task.

I had to figure out a way to grow. Setting forth on a deliberate path toward leadership growth marked a significant turning point in my professional path. I shifted my focus

toward transformative leadership consulting. Driven by a passion to eradicate toxic workplace cultures, I began to develop leadership programs and coach leaders, executives, and individuals to reclaim their power and take ownership of their actions. As I delved into my own leadership journey, including seeking guidance from diverse mentors, I discovered the importance of discovering my core values, and my "Why."

Though I made the conscious decision to stop leading through fear right away, it didn't erase the lingering unease I felt about my boss's potential future actions. Nevertheless, it gave me a newfound clarity on how I would navigate and respond to any challenges that lay ahead.

After my boss left the organization, optimism became a guiding force in my leadership approach, bringing hope and confidence into my team's work. I intentionally allowed myself to be authentic, which rekindled genuine connections, empathy, and inclusivity, and took opportunities to recognize the contributions of each individual. Courage and transparency became important to me, I worked hard at being open in my work and leadership. Embracing bravery, I confronted challenges head-on through learning different ways to have courageous con-

versations, disagree constructively, and resolve conflict, to instill a culture of resilience and trust within the team.

Through my journey of self-awareness and values alignment, I discovered my true north, shaped by the principles of personal empowerment, optimism, authenticity, courage, and value-driven leadership. These tenets hold the power to dismantle toxic work environments and pave the way for a brighter, more inclusive future. It is this true north that helps me reassess, self-correct, and prevent me from ever again becoming a toxic leader.

Key Takeaways:

Understand that toxic behaviors can seep into your leadership style if left unchecked. Embrace self-reflection and accountability to address any harmful tendencies and to foster a culture of awareness and growth. By staying grounded in your values and retaining personal agency, you pave the way for positive transformation within yourself and your team.

Michele Lau Torres

M ichele Lau Torres is an accomplished organizational talent and learning leader. With over 20 years of expertise in performance and organizational development, she is a recognized culture and talent strategist, equity champion, and transformational leader.

Michele strategically designs and implements initiatives to enhance organizational culture, innovation, and employee engagement. As an independent consultant, she collaborates with clients, contributing to the development of strategic leadership roadmaps and organizational culture redefinition.

Michele aspires to further her impact by becoming a sought-after industry speaker and influencer. Beyond her

professional pursuits, she brings a global perspective having worked and traveled extensively to Australia, Europe, and Asia.

https://www.linkedin.com/in/michelelautorres/

2
Five at a Time

Kelly Griggs

Savannah: Restaurant tacos and lemonade tonight, Mommy?

Me: Does your tummy need some special Friday food?

Savannah: No, you do; you're yawning and look sad. My brain needs fancy chicken to help it grow!

Me: I love you sweet girl...restaurant tacos, here we come!

Fridays were special because it was the one day during the week that I actually felt like a normal mom taking her child out to dinner. The bystander didn't know that I had this excursion carefully planned out. On Friday night at Wahoo's Fish Tacos, they had a special of $2 tacos. My

guess is they wanted to draw people in who would then drink several beers out on the patio, maybe add on a dessert or two, you know, since it was Friday. I don't imagine Wahoo's did their $2 taco special for a broke, single parent like me.

I felt like I got a hidden treasure every time I went there. Seriously, how did these people not know how much food they gave away? The $2 taco came with two tortillas and enough fish to split and make two full tacos. I always ordered a la carte, and nine times out of ten the kitchen would still put the side of beans and coleslaw in the basket. So we got a FULL meal for two people at only $2!

Savannah's other favorite thing was "restaurant lemonade." We would ask for water cups and they had a large bucket of fresh lemons anyone was welcome to put in their drink. Toss in a sugar packet or two and my three-year-old daughter was in heaven. The mom in me felt good because her "fancy chicken" was decent grilled fish. And since good old Wahoo's knew how to cook their fish much better than I did, she never knew it was fish, and I allowed her to think it was just different chicken.

Back at the apartment, it was bath-teeth-bedtime stories and then precious sleep for her. As for me? After I put

Savannah to bed, I'd start my second shift for the day. Most days it was grading papers or lesson planning for my sixth-grade class. Other times it was working on one of the many restaurant training manuals I created for either a restaurant I had worked at during the previous summer break or wanted to work at for the upcoming summer. That work paid decently and enough of the restaurant owners would offer me cash, under the table. Which was perfect because I needed every cent I could put in the bank.

Now the third second-shift option I had many Saturday nights was to wait on the rich, happy families at the Colorado Rapids Major League Soccer home games. I was responsible for anywhere between three to seven suites at the stadium. The people usually tipped well because they all wanted to impress each other. The wives seemed to focus mostly on the other wives' newest accessories.

"What a great purse Sarah!" or "Where did you get those new Tory Burch shoes Kim?"

The biggest gut punch was "Oh, what a fabulous ring Karen, is that your new baby's birthstone? How sweet is that hubby of yours!"

Meanwhile, I would grab toothpicks and pause in be-tween suites to push out the smashed french fries from the grooves of my restaurant shoes. The non-slip shoes we were required to wear were hideous and most definitely made you slip when fries got stuck in the bottom. While I knew my second job (or was it my third?) was one I needed to keep because the tips could be lifesaving...I also hated it because those were the only nights I didn't get to put Savannah to bed.

Of course, I was thankful my parents watched her so I could keep the job and not worry about how late the shift ran. The stadium was forty-five minutes from their house, which was the opposite direction from my apartment, and I would sometimes be stuck cleaning out the suites until midnight. I always got a knot in my stomach the next morning hearing how much fun Savannah had at Nana and Papa's house. I was envious of how easygoing and relaxed my mom was with Savannah. No matter how hard I tried, I seemed to always be a stress case. Possibly that's the beauty of being a grandparent, you don't have the day-to-day stress of raising the child. Yet I always felt like I was the only one in the world waking up with clenched fists and a furrowed brow.

When would I ever be able to relax?

Never, I'd remind myself. *You are a broke, single parent, and a teacher no less. Good luck getting ahead.* This was my life, and I needed to just own the fact that I would be a frantic stress case for the rest of it; I didn't see how it would ever change. I also reminded myself that I chose to be an elementary school teacher. I did that when I found out I'd be raising Savannah on my own. I looked at all the professions my undergrad degree could be used for, and teaching seemed to be the only one where I would have the most time available with my child. And I was good at it. I loved teaching kids how to read, write, and essentially think for themselves.

If I'm being brutally honest about raising Savannah as a single parent, I actually made that choice as well because I never asked her biological dad for help. True, he had never met her, never answered my letters, emails, phone calls...plus he was across the ocean on an entirely different continent. Possibly he was just too busy chasing women to respond.

While I knew I could use the monetary support, I didn't want to risk that he could possibly take her away from me. I'd rather work five jobs and never sleep than have that be a possibility. I reminded myself that this was just my lot in life and to at least be thankful I had a healthy, smart

daughter who made it all worthwhile when she hugged me tight and called me mommy.

Now, don't get me wrong, I was continuously scouting for good dad material. Secretly, I focused on men with blonde hair and blue eyes, thinking they could also pass as the actual father of my child. And I was trying to stay away from men who enjoyed chasing women. That lesson was burned deep in my soul. I would sometimes daydream about having an actual partner who made me laugh and took Savannah out on father-daughter dates. But the main focus was to find one who wanted to be Savannah's dad and who would take away the panic I had when my car wouldn't start or a bill came in the mail higher than expected. I dreamed that having a partner would allow us to breathe. So, search I did! I checked out men's left hands when we were at church, the grocery store, any offsite teacher meetings...you name it. As my luck would have it, I met some genuine frogs who pretended to like that I was a 24/7 single parent, yet when reality shined through, they ran as quickly as possible.

A little excitement popped into my life when my parents started planning their retirement. My mom is also a teacher, so hearing her talk of the pension check she would receive every month for the rest of her life put a little giddy

in my step. I could make it thirty years teaching and then have a decent paycheck guaranteed forever! And then I'd think...thirty years teaching? Holy $#%! But that was at least something I could count on and continue to work toward. However, this was in 2007.

So if you know anything about what happened to the stock market in 2008, you'll know that my excitement for my parents' retirement probably changed to dread when they lost nearly 40% of their "nest egg" in the market crash. I began listening to my parent's concerns and started asking questions of my own.

"Everything you've saved for retirement dropped almost in half and there's nothing you can do about it?"

It made no sense to me. What made the conversations even tougher was when my mom learned her school pension was now "insolvent." I wasn't even sure how that could happen. Teachers who were about to retire after thirty plus years of being in the classroom were all but running around with their hair on fire as the news spread.

I started doing my research on how a state pension could be mismanaged so badly that the funds from hundreds of educators could essentially evaporate. I tried asking ques-

tions directly to my principal in our Monday staff meeting.

"Do you know what's going on with all of our retirement money? What should we do, as teachers, since the funds are taken out of our paychecks each month and we have no say in it?"

She called me into her office later that day and reamed me out. She said I made the school district look bad. And then she asked me if I wasn't as devoted to my students as I said I was. This made me feel like my concern for my personal financial future was selfish compared to focusing on what my students needed from their teacher.

I look back on that time now, and after the self-care I've worked on over the years, I know you can't pour from an empty glass. And my glass, at that time, was virtually nonexistent.

How most pensions work is the employee is required to contribute a percentage of their salary and the employer either matches that percentage or sometimes contributes more. In my and my mom's school district, 7.6% was automatically taken out of our paychecks each month. So I could do that math—7.6% x annual salary x 30 years and you could get ZERO DOLLARS?

I didn't stop researching and learning how a market downturn could literally evaporate decades of savings. I came to understand that markets typically correct themselves and downturns eventually go back up. But for people like my parents who were standing at the door of retirement, they didn't have any time left to recover. They did what a lot of 62-to-65-year-olds did in 2008 and 2009...they kept working. And I continued digging into different savings and investing strategies. One concept that kept coming up in my research was to "diversify" your investment holdings. If you are overweight in one sector, for example, real estate, that overexposure can snowball with losses from additional sectors that are closely related and could also face a downturn.

As I kept learning, I started putting that new knowledge into practice and actually started saving. I wanted to save outside of my teacher pension, for obvious reasons, so I started with a simple savings account. At first, I felt stupid even walking into the bank. I was scraping pennies to make it through each month and now I thought I could save money? I felt like a fraud.

Somehow I did find a way to squirrel away some money. While I still needed to dress my ever-growing child, I found a thrift store specifically for kids where you could

sell clothes, shoes, and toys that were in good condition for either cash or toward other items that they actually needed. This was life-changing. Most of the time I would take in gifts sent to Savannah that didn't fit her or that she didn't need, and leave with not only clothes that fit her but most actually still had tags on them. Sometimes I left with clothes AND cash! I made it a game with her, to see if we could take items in, and leave with something she needed and money in my pocket.

What is interesting is that even though I was saving sometimes only five dollars at a time, it started to change my thinking and feelings toward money. I began looking for any additional ways I could make money work in my favor instead of feeling like a slave to it.

I will not lie and tell you everything changed overnight. It didn't. But slowly, I started to change. The mantra that had been running through my mind for almost a decade, "broke, single parent" was gradually replaced with kinder, more self-fulfilling words like "hard-working teacher, dedicated parent."

Instead of thinking I needed to meet a man to "save us" and be a dad to Savannah, I began telling myself that I was

enough and that my strength and love for my daughter was enough for a happy life.

In our teacher's lunchroom, a coworker bought a house near our school and boasted that her mortgage was less than their rent.

Excuse me? I froze in my lunch seat.

A thought hit me. *Could I?*

Noooo.

What if?

Nooooo.

A broke, single parent couldn't be a homeowner.

Then I stopped myself, as I often did and replaced those words with a "hard-working teacher, devoted parent." That type of person could become a homeowner!

Little did I know that the church Savannah and I had been attending for years had a down payment assistance program that I qualified for. And when I started really looking at those five dollars saved, I could see it slowly turning into thousands over the next few years. It becomes

life-altering when you open your eyes to possibility versus scarcity.

I became a homeowner that next year. It was every bit the kind of fixer-upper eyesore you see on TV shows...bubble gum-pink walls inside and mismatched patchwork paint on the outside. However, with a lot of sweat equity, we made that home uniquely ours over the years. With the help of my mom, we dug up and redid the front yard, finished the basement, and moved the washer and dryer out of the kitchen. I bought power tools, made my own shelves and a desk for Savannah. I furnished the entire house with purchases from Craigslist over the years (this was long before Facebook Marketplace). I could find newer items particularly when someone had a moving sale. Sometimes I would get a piece of furniture I knew was an excellent brand and had good bones, but just needed some TLC to make it pretty again. I would eventually repost it on Craigslist and resell it for more money than I paid.

I also didn't stop learning about the financial industry, so much so, that I decided to study and get my Series 6 license. This is a certification process issued by FINRA (Financial Industry Regulatory Authority) that enables an individual to sell and manage financial accounts for others. My only thought for getting that was to help educate my fellow

teachers on how to save outside of their pension. In order to get that license and actually do something with it, you have to be employed with a broker dealer. With enough determination and research, I found a former teacher who had left the profession and was now a principal dealer at an insurance firm. I dove into taking my securities license with the same fervor I did to achieve any of my goals—all or nothing!

At this point, being a homeowner (all by myself!) and able to save money each week, I began to actually feel like a worthwhile, smart, successful person. I started to turn down dates from men who:

a) didn't have their life together and

b) were not gentlemen.

If a man was crass toward me or about other women, I would tell them to not bother calling me again. One date I'm quite proud of NOT going on was when this good-looking, successful man, a man I would have tripped over myself years before, came to the door to pick me up WHILE ON HIS PHONE and then continued berating his ex-wife about child support as I trailed behind him toward his fancy, expensive car. As he opened his door (not mine), I heard him say she was f*&^% worthless. I quietly

closed my door, walked back inside my house, and never turned back around much less returned his phone calls.

I eventually sold that house for over $200,000 more than what I paid for it, and Savannah and I moved to Austin, Texas. She wanted a fresh start...middle school had been rough on her sweet spirit. And truth be told, I couldn't get people to look past me as Miss Freeman the teacher, to Kelly the financial planner. So we both took a big chance and let go of the known in favor of the unknown. With a big gulp, I resigned my teacher position that May and went all in as a financial planner.

When we moved to Austin, I continued financial planning for people who were depending on a pension for retirement as well as broadened to help families build wealth outside of their 401k and other tax-deferred plans. I eventually earned additional licenses by taking the Series 63 and 65 exams.

One of the hands down, best things I did was get 100% intentional about who I spent time with. I took a long hard look at who I spent my time with over the past fourteen years as a single parent and could clearly see the people who were supportive and encouraging. I decided that with this fresh start, I was going to seek out other women business

owners who were putting their all into each and every day. I purposely left out the men in this new plan because I was tired of the games. I think I would have enjoyed having some male friendships and their different perspectives and experiences in life, but being single seemed to make that impossible without complications I didn't have the energy for.

And as far as dating, I was waving the white flag. I'd made it as a single parent for this long, I finally decided I had to be enough. I began to embrace who I am, what I'd accomplished, and how I had persevered through the years. Surprisingly, I began to actually like myself. My mantra became, "It's better to be alone than with the wrong person." I spent sincere time, almost daily, on self-improvement, whether it was reading finance books or podcasts on overcoming obstacles in life. I began having conversations with other women about the power of saving and understanding your finances. I was keenly aware that my mindset of abundance and opportunity had a positive snowball effect on my life. I made conscious financial choices in my favor versus doing what everyone else seemed to be doing. I didn't buy new, expensive clothes; I found consignment stores were my gold mine. The bonus was that I got a lot more enjoyment out of buying something new to me that

made me feel good about myself and was a fraction of the retail price. I drive a nice car that just happens to be over ten years old. And I continue the "sweat equity" route for each house I purchase.

After embracing the concept of diversification I learned when I started in the financial industry, I dug deeper and found the most financially successful women utilized this beyond just the investment sectors. They diversified their savings in multiple, separate pillars such as ones that grew tax-free, others that had heavier market exposure, and ones that offered risk management plus protection from loss. I worked with enough women by this point that I saw firsthand what could happen if the woman didn't have any knowledge of her own finances.

I believe in putting your money where your mouth is, so I created these pillars for myself and my daughter.

Today, I find the most enjoyment in working with women who are interested in a secure, sound retirement that covers life's known unknowns and allows them to not only sleep well at night but wake up each day knowing they get to live life!

And then...when I finally decided I didn't need a man to be a dad for my daughter or a partner for me...that's when

I met him. Insert Adam into our life. A man who thinks I hung the moon everyday, no matter what kind of crazy hair I wake up with or the roller coaster of hormones we start to get in our forties. What I do know is that I wouldn't have been ready to love someone until I finally loved myself. And I guess it just took me a bit longer than most....

While Adam and I were planning our wedding, Savannah, now twenty-years-old and a senior in college, decided to move back home and finish college online. She said it was because she hated living out of state, but I think she likes this family we've created. She sees how Adam treats me. She sees how I put him as a priority in life. She joins in our laughter daily, and I think feels a part of the love and respect we have for each other.

She saw me struggle and fall so many times over her twenty years. Yet, what matters is that I always got up. Instead of continuing the "poor, broke me" routine, I changed my mindset, how I talk to myself, and I figured out a way to make myself proud of myself.

She asked if she could take his last name while we were planning our wedding. Not only did I meet a man who chose me and my daughter...she chose him right back.

It blows my mind how life can come full circle from your heartache and tears in your pillow to a thing of beauty that wouldn't have been so precious had it happened when you wanted it to.

Key Takeaways:

When you change how you talk to yourself, you slowly change the story that's repeating in your head. This is when you can actually change the direction in your life.

Small changes do add up, just like small savings can grow and multiply overtime. Five at a time relates to money, your thoughts, your choices in life. You are the only one who can make your life what you want it to be...so be conscious of where you spend money, who you spend time with, and most importantly, what you say about yourself to yourself.

Kelly Griggs

K elly Griggs serves as the Vice President of Financial Planning for Boyce & Associates Wealth Consulting. As a Financial Advisor, she holds multiple advanced licenses including Wealth Management Specialist and Chartered Retirement Planning Counselor. Her passion is to guide women on how to plan a secure retirement and own their financial life.

She was born a Texan, lived most of her life in Colorado, and has come back to her roots in Texas. Kelly has one daughter, Savannah and a bonus son, Reid. She recently married her soulmate (he did, in fact, exist!) Adam Griggs, a retired firefighter and now Unit Chief, Watch Commander at the Texas Division of Emergency Management. Kelly is also the founder and President of *Networking*

BossBabes, an organization of thirty-plus women business owners in the North Austin area.

https://www.facebook.com/kgriggsplanning

https://www.facebook.com/profile.php?id=1000070061 89147

https://www.instagram.com/kellykfreeman/

3
The Saga of a Rested Rebel

Kibi Anderson

How the hell did I get here? This is the question that kept going through my mind. Deep down I knew the answer, but at that moment I was still looking for a way out of owning the truth. Looking down at my legs, skinny, ashy, and covered in so many dark brown scabby wounds, I became overwhelmed again. My tear ducts filled as the image before me escalated the anxiety in my body. Would anyone ever truly see me as beautiful again? My smooth-as-a-baby's-bottom, caramel-colored calves were once a part of my body that received glowing compliments. The vibrance of perfectly toned muscles glistened as I

walked down the street. They made me proud, and it felt good to say in response, "Thank you. I got them from my mama." Reveling in the adoration of so many, my vanity was on full display. Now looking at them made me want to throw up.

Sitting in a hospital bed at 12:23 p.m., I couldn't get comfortable no matter how hard I tried. It was a sunny day in February, and by then I was on day eight, and the daily cacophony of constant beeps from all the monitors—oxygen, blood pressure, and IV drip pole—made sleeping impossible. My right hand throbbed, each finger resembling small Vienna sausages due to inflammation. No rings for me now. The sour smell of the hospital room and the slightly warmed, rough, and rigid sheets wrapped around my ankles felt like shackles. I was trapped and wanted to get out of this cycle of suffering. But I didn't know how.

My journey to this day started ten years earlier.

It was a breezy spring evening, and I had just finished working another twelve-hour day. That was my usual work rhythm then. My left ankle had been bothering me nonstop all day, but I had ignored it, instead pushing through the pain because I had an important deck to finish. *Shit, I don't have time for this.*

Two months later, while sitting in my Brooklyn brown-stone apartment, examining the newly painted red kitchen walls, it happened again. My right ankle was swollen this time. The heat radiating from the robust, textured skin mirrored the tempting allure of a perfectly smoked turkey leg. I detected a small pus-filled blister forming on top of the inflamed scarlet skin. Placing my palm gingerly on the area forced a wince due to the pulsation of the pain shocks it triggered up and down my leg. I thought, "Damn, did I get bit by one of these New York City super mosquitos?"

It was a hot July afternoon in the boroughs, humidity was thick, and the bugs were in abundance. I had uprooted my life to move from Los Angeles to New York City to start my first year of business school at NYU Stern. After running more tests at the urgent care center down the block, the lovely Jamaican doctor looked closely at the pustule on my leg and shared, "The tests aren't coming up with any specific issue—no fever, white blood count is fine, and since you are new to the city, it probably is a reaction to something you ate or a bug bite." Relieved, I took an antibiotic prescription. He went on, "Yuh, sound like yuh been through 'nuff stress lately, especially with di move. Mi recommend yuh tek some time fi yuhself, ease up off yuh feet, and get some good rest."

I smiled, concealing an internal inferno blazing within my mind at a five-alarm intensity. A deluge of concerns inundated my thoughts as I left.

Are you bugging?! You want me to rest? What planet are you living on? I have classes to take, homework to start, internships to apply for!

Each thought landed like a strategic punch in this mental boxing match for the championship title for my future. As I walked home, the intensity of the summer heat sucked the air out of me, and I stumbled, grabbing a nearby stair railing to provide support. My legs collapsed on the bottom stairs of the attached brownstone.

Illness 1, Kibi 0.

Peering up at the blazing sun, I closed my eyes and exhaled. *Get it together, Kibi.* My hard-earned future hung in the balance; a tiny bug wouldn't derail my pursuit of next-level success.

Hobble here. Hobble there. Hobble everywhere.

I endured a relentless cycle for the next ten years: inflammation progressed to body sweats, chills, and 105-degree fevers. It turned out that the small pustule on my leg was not a bug bite. It was my first ulcer. The excruciating

process of ulcer formation is marked by blistering and searing pain akin to a blow torch, that persists for four to five agonizing days. In desperation, Percocet became my reluctant ally, offering respite from the torment. Stricken with weakness, I lay incapacitated for days, as more ulcers manifested on my legs.

The unpredictable journey through ulcer healing unfolds as the pain recedes, revealing the true scale of the damage. A morbid countdown begins as the deadened skin transforms into a grotesque, dark scab, eventually unveiling wounds spanning one to four inches in diameter. The arduous process of complete healing extends over a painstaking four to six months, during which my legs are ensconced in layers of bandages. At one point, I had eight open ulcers on my lower legs at one time. Relentlessly, each wound oozed a putrid, continuous discharge, a thick, yellow mucus with an odor akin to a nauseating blend of rotting garbage and vomit, leaving me teetering on the brink of dizziness and nausea.

Diagnosed with the rare autoimmune juggernaut Pyoderma Gangrenosum, or "PG" for short, my only options were medication or a radical shift in lifestyle. Nine relentless years, nine brutal rounds in the championship bout for my future. From medical professionals to reiki healers,

even strangers on the street, the consensus reverberated the need to slow down, rest, and quell stress. Despite the chorus of well-intentioned voices, I clung to medication, forging through years of hospital stays and unrelenting pain, accumulating forty-five ulcer wounds on my journey.

That's how you got here, Kibi.

This was the honest answer to my opening question, and ten years later, I sat in a hospital bed yet again. Wordless and shaken, the gravity of my situation settled like an oppressive weight, crushing the air from my lungs. As I tried to breathe, I felt the relentless truth closing further in on me—I had convinced myself that outworking my illness was the only path to victory. Yet, it dawned on me, clear to everyone but myself, that this relentless pursuit was leading me toward an early grave, a paradoxical salvation. A deep, guttural moan, sounding the pain of countless sleepless nights and agonizing hours in the cold stillness of ER waiting rooms, reverberated within my chest, a testament to the toll my relentless journey had exacted.

Within the sterile confines of that hospital room, my internal soundtrack played a relentless loop, each note a self-centered refrain: *Why me?* A solitary question echoing

the isolation of my struggle against an unforgiving fate. I was jolted back to reality by the voice of one of my dearest and realist friends, Aida. "What's going on Sunshine?" she announced with exuberant joy as her five-foot, ten-inch (six foot in heels) goddess legs walked into the room. Her smiling face, framed by unruly brown curls gathered in that familiar messy bun, infused my heart with a soothing calm, a sanctuary in her comforting aura. Under my breath, I said a quiet directive to God, "I'm not finished with you yet, so hold on," and I shifted my focus to answer her inquiry. "I'm hanging," I muttered, the reflexive response that parroted through those challenging days.

Aida, a professional comedian, usually served as a source of hearty laughter and heightened productivity during our decades-spanning friendship. Our exchanges were typically filled with banter, shared laughter, and reflections on the wild experiences we'd encountered. However, this contact carried an unusual weight. Beneath her usual warmth, I sensed profound worry. After ten minutes of our usual repartee, Aida's laughter ceased. Her demeanor shifted, and she surveyed my eyes with an intensity that seemed to penetrate my very soul. As her pupils dilated, she posed a simple yet haunting question, "So, Kibi, how long are we gonna do this?" Staring back at her, I found myself

speechless, frozen as though facing an eight-foot bear on all fours in front of me, mouth wide, fangs bearing out.

I regressed to the vulnerability of nine-year-old Kibi, facing a shutdown from my mother. Blinking back the emotional pounding, she pressed on, her words a stark reminder of my achievements and untapped potential. "Kibi, you're brilliant, a Harvard graduate, a problem-solving consultant for global CEOs. Bitch—you have an Emmy! So here's what I don't understand. Why can't you seem to harness all that brilliance to heal yourself? Because if you don't, I'm afraid you are going to die." The weight of her concern hung in the air, a dire prediction of self-destruction. As she rose, warmth turned to an embrace, her hug lingering, a tangible connection to her plea before she left the room, leaving me with her words ringing like an urgent call to action.

I teetered on the edge of unconsciousness as the moan threatened to suffocate me, until, like the breaking of a dam, I shattered. What had started as a mere moan escalated into a primal wail, unleashing heaving sobs that seemed to repeat across generations, a pain inherited from my ancestors. In that moment, evasion and deception were stripped away; no more intentional prolonging of my suffering, no more surrendering my power to well-meaning

but helpless doctors. The realization hit me like a thunderclap—no saviors were on the horizon. Left with no more excuses, I confronted the million-dollar question I had evaded for so long: *Kibi, why are you so unwilling to rest?*

Thus embarked my relentless quest for answers. I began with a Google search of that question: why are you so unwilling to rest? The ominous headline "Only the Overworked Die Young," in the list of search results immediately caught my eye. It outlined a 2015 Harvard Medical School study that echoed a truth familiar to many, including myself, who have, at times, pushed their limits to consistently work eighty-hour weeks. The results laid bare the consequences of overwork on health, revealing a 13% spike in heart attack risk and a 33% increase in stroke likelihood for those working fifty-five or more hours a week. Operating on this relentless schedule, the body's desperate pleas for rest become drowned out by the incessant demands of daily life. Despite a $1.5 trillion self-care industry and a plethora of life-easing tech gadgets, the exhausted still dominate.

Each coffee sip interrupted by work notifications, every attempt at lull shattered by the intrusion of children into bedroom sanctuaries, I found myself ensnared in a pan-

demic of depletion. I was entangled in a relentless narrative that rang, *I don't have time to sleep, I have to be there for the kids, my team, my parents, my friends, my church, my community.* A perpetual employee of the month, I had come to view rest as a rare luxury, granted only after the accomplishment of tangible deeds. Achievement and hard work were my golden ticket to a life where I would never be broke, hungry, or alone. Estranged from a father who battled drug and alcohol addiction all my life, I grew up in a single-parent household with my mom. This meant that I had to learn survival skills, usually reserved for adults, as an eight-year-old child.

Programmed by societal norms rooted in capitalist ethos, my existence seemed bound to the conviction that my value hinged on relentless productivity and sacrifice, a narrative particularly potent as a woman. I wore the self-imposed pressure to work incessantly as a badge of honor, a zombie navigating life with a perpetual sense of doing, blinded by the belief that rest must be earned. The familiar refrain of *once I finish the work, then I'll rest* resounded not only within my mind but resonated among countless professionals and friends. Years of this distorted mindset was clearly killing me. I wanted off this ride.

My desperation produced a cascade of questions: Has any-
one ever taught me the art of rest? Did I witness my mother
or anyone in my close-knit community master the tech-
nique of slowing down? Amid the grating voices advocat-
ing for balance and self-care, I found myself taking vaca-
tions, engaging in Vipassana meditation, and prioritizing
sleep, only to discover that I was still f-ing tired in my
bones. The conversation about pausing seemed reserved
for the privileged, those with the luxury of financial ease.
Solely responsible for my livelihood and the welfare of my
family, I found myself trapped in a skeptical circle, seeking
guidance that remained elusive. The outside world offered
no viable approach to quell the notion that rest was a
luxury beyond my grasp.

I pushed back against every suggestion to hit pause because
I couldn't fathom that rest or slowing down held the key to
solving my struggles. Being a strategist and consultant, my
career thrived on diving deep into data to untangle chaos
and find solutions, especially in the murkiest situations.
So, my natural instincts kicked in, urging me to analyze
the data. At its essence, embracing rest is an act of trust,
but strangely enough, I had never dared to place my trust
in rest over ceaseless work. What was crystal clear, though,
was that my current hustle wasn't yielding the healing I

craved, and by then, I was miserable enough to consider trying just about anything.

So as a maker of pathways forward in white space, I considered a new approach. What if I flipped the entire program on its head and started with the belief that the current story I was telling myself was a lie. If I reversed the old logic that rest is a luxury derived from work, and instead shifted to believing my PAUSE was the source of all strength, success and output, what would my results be? My mantra became: You're not getting the results you want, not because you aren't WORKING hard enough, but because you're not RESTING enough. The best WORK results are the byproduct of a power-filled PAUSE, not the other way around.

If pausing is the wellspring of power, then my next step was to delve into a profound understanding of it. The Oxford Language Dictionary defines pause as "a temporary stop in action or speech," and rest is to "cease work or movement in order to relax, refresh oneself, or recover strength." Well, that was interesting because my lived experience said otherwise. While, yes, it could involve the act of no movement or work, it didn't have to. In practice, I had indulged in non-work spa retreats, vacations, solo meditations, and even the occasional night of deep sleep—each proving in-

sufficient in the pursuit of genuine rest. How many return from a vacation more fatigued than when they departed?

As I delved into myriad magazine and media articles extolling the virtues of life balance as a gateway to rest, my personal experiences contradicted this popular wisdom. Balance is a notion that feels akin to teetering on a seesaw, perpetually shifting weight to maintain equilibrium in a fixed state. In order to make space for one thing, you have to take away something else. In order to make time to rest, you have to take time away from work or with your kids. For me this constant juggling act always fostered a scarcity mindset, instilling guilt for every choice. Rest couldn't be about aiming for balance, because who wants to feel guilty all the time? It's a choice I would never consistently prioritize, no matter how pretty the retreat pictures looked online. Had I fallen victim to the illusions of the self-care industry once again? If rest was the true goal, balance could not be the path.

Lastly, I took a critical look at the prevailing idea that rest must be a solitary pursuit. Days spent alone on the beach, yearning for solace, left me empty-handed and questioning the validity of the notion. Contrarily, a few afternoon hours in a roller-skating rink with friends proved more invigorating than a full eight hours of sleep, underscoring

that rest can flourish within the communal embrace. This realization shattered my belief that navigating the journey to rest must be a solitary endeavor; in fact, there's no need to face it alone.

Empowered by a foundational hypothesis, I dove head-first into the mission of constructing a framework that could finally dismantle the trust issues tangled up in my dance with rest. Without a solid system, this whole experiment would just crash and burn. Drawing on my consulting acumen, I crafted a multi-step framework—versatile enough for any situation where the choice between rest and work loomed. With three key mindset shifts at its core, this blueprint ensured I always maintained a commitment to prioritizing rest, even when anxiety was howling at the door.

The first was a shift to an abundance mindset. When it comes to potentially threatening decisions, our brains are hard-wired to choose the negative narrative because of our primal instinct to survive. Thousands of years ago, the one time we didn't immediately run when we heard rustling leaves in the bush meant a tiger waiting there would have no problem eating us. Today, there aren't many tigers roaming the streets of any city in the USA, but we are worried about losing our jobs, asking our bosses for a raise,

or firing our problem employees. Our bodies can't tell the difference emotionally, even though the danger isn't life or death anymore. So we tend to operate with a fixed mindset.

I, too, had been conditioned to think about rest from a place of scarcity, so when confronted with a potential threat, my instinctive reaction was always to run through a list of three common fear-based questions: What can go wrong if I rest? What can go wrong if I pause? What can go wrong if I'm not there? The flaw in this approach lies in its inherent paradox—what you feed invariably flourishes, and fear, with its insatiable appetite, is no exception. My relentless efforts to outwork and outrun the fear within proved futile, an unending cycle that only produced more stress and anxiety.

Embracing the notion of an alternative, abundant mindset was a formidable challenge, a departure from the familiar but desperate path I had been on for so long. So, I scribbled these questions down, flipping the script from scarcity to abundance: What wonders might unfold if I welcomed rest? What beauty could blossom by centering my life in harmony? What positive shifts awaited me if I hit pause? This little exercise sparked a revolution within. I realized that the very moment I feared taking a break, all the grind

in the world would forever leave me wanting. It was time to rewrite the rules.

The second pivotal shift came as I transitioned my mindset from "me-care" to "we-care," dismantling the quandary that had plagued the pursuit of self-care as the ultimate goal. It's time to expose another societal myth: Self-care is not the goal. The delusion of self-care lies in its implication that caring for oneself excludes care for others. It's a misleading narrative that convinces us that, without our personal intervention, everything will collapse. This egocentric perspective, upon reflection, became glaringly clear. Ladies, we are important. But we aren't THAT important. Rest becomes your love language to everyone in your circle. It tells them that you value them enough to show up as your best, most amazing, brilliant RESTED self. Your pauses actually benefit everyone you care about and are leading, because who honestly enjoys interacting with a bitchy, cranky, sleep-deprived, impatient version that shows up when you're tired?

Enlisting a we-care mindset tells your team, family, and community you are certain they are capable of getting the job done because as their fearless leader, you've adequately trained them to be that good. If you don't believe that, then it makes me question your capabilities as a teacher

and coach, not theirs. I switched my focus to owning only my part of the work I can control and letting others do their part. As a self-professed control freak, this part initially made me hyper-ventilate because clearly, I am always right! But after taking a few deep breaths, and taking the time to answer my three "abundance-based" questions, I calmed down.

1. What wonders might unfold if I welcomed rest? *See the glee on my twelve-year-old bonus-daughter's face when she brags about the amazing breakfast she made herself while I was on a walk.*

2. What beauty could blossom by centering my life in harmony? *Enjoy the pride of watching my direct report confidently lead his first team meeting.*

3. What positive shifts await me if I hit pause? *My business is mentioned by others in new spaces producing significant client referrals while I'm on vacation.*

The final step in my transformative journey centered on embracing rest as a consistent and disciplined lifestyle practice, a stark departure from my previous chaotic and sporadic approach. The challenge lay in redefining my

boundaries. The scars etched on my body bore witness to the toll exacted by this exposure to chaos. Faced with no alternative, mastering the art of confidently saying NO became an absolute imperative. The mantra rolled incessantly until it ceased feeling foreign, crystallizing the empowering realization that "No is a complete sentence. No is a complete sentence. No is a complete sentence."

With Aida's words ringing in my ears, I took the leap of faith and surrendered to the pause. The experiment would last for six months to start, because I had enough savings to last for a year, and my contingency-focused heart couldn't handle more. I plunged into a radical transformation, deliberately stopping my hunt for work, and purposefully departing from six volunteer boards. The carefully crafted professional looks and makeup found sanctuary back in cabinets, replaced by the simplicity of freshly washed makeup-free skin, leisurewear, sneakers, and jeans. Battling the reflexive urge to say yes to demands for support, attendance, and promotion, I wielded the power of "no" with unwavering commitment, guided by my steadfast framework. The results were profound—I parted ways with friends and briefly became estranged from my mother, a stark reminder that not everyone embraced my imperative to prioritize self-care unequivocally. Yet, some rifts

unearthed a blessing in disguise, exposing relationships that had perpetually been one-sided and laden with judgment.

I ditched all those "have to's" and traded them for the sweet freedom of "get to's." That meant diving into epic foreign films with subtitles, losing myself in sun-soaked books in my cozy sunroom, taking leisurely strolls around the neighborhood, catching up with friends, old and new, on random Tuesday afternoons, sailing on weekends with pals, and whipping up gluten-free dessert magic in the kitchen. Now, let me tell you, breaking away from the idea that work equals safety had me waking up in a cold sweat for weeks. At first, I despised it, labeling it a crappy excuse to dodge life's responsibilities—because, you know, carefree days were only for the lazy or the mega-rich, and they were definitely lazy! But as the days rolled on, and my commitment to savoring these simple pleasures stayed strong, my soul got hit with these tiny, electric bursts of joy.

After six months, my body responded in the most miraculous way. With the time and space to finally take inventory of the quality of my doctors, medications, and choices around food and exercise, I observed trends. I cut ineffective medications. I engaged new specialists with updated

protocols. Suggestions to cut sugar and meat intake became real alternatives I finally had the time to try. I stopped getting new ulcers for the first time in over five years. Four wounds were still in the healing process, so despite my desire to swim in the ocean, sitting by it on the sand in my bandage-wrapped legs was the closest I could get. But what if continuing my pause would give me the homecoming to liquid serenity I had been seeking for over two years? I decided to stay the course for another six months. Savings be damned, this felt amazing.

This extension unleashed a level of breakthrough in my professional life that still leaves me amazed today. One of my favorite pastimes during my pause was chatting with new people with no agenda other than learning about their personal stories. I'm a storyteller at heart, so this experience always left me energized and light. During one such phone call, the person asked me out of the blue, do you coach by chance? For the last five years, I had provided coaching support to senior leaders and entrepreneurs on a part-time basis via referral only. It wasn't something I promoted publicly, though, so this question shocked me. I had never met this person before and answered affirmatively, with a hint of astonishment in my voice. That single question resulted in a lucrative coaching contract with a

global media company. I made more money during that six-month period than my full-time salary at my last job, doing work that required a tenth of the time. By reluctantly pausing my old frantic job search, I enjoyed the financial rewards that came effortlessly to me during my pause.

Coaching work energized my body in a way that fueled my cells. By the end of that period, my ulcers were fully healed and I was able to reunite with the ocean's waves in a cherished elemental embrace. After the extended hiatus, the feeling of slicing through the water was more than a swim—it was a homecoming that removed any doubt that I would ever return to my old ways. While I'm not a medical doctor, my experiment produced results beyond my wildest dreams. I healed and paused without sacrificing my livelihood and my security. Instead, I received the clarity, money, and time to enhance my life in new ways I never made space for before.

Rejecting the conventional doctrine that rest can only be accessed by stopping work was the key to unlocking my ability to pause successfully. What emerged was a cycle of days filled with activities that I loved to do, which produced more calm and inner peace, and charge than multiple days of sleeping and vacations. So I decided to redefine rest as "doing anything that gives you joy." This

definition provided a more accessible gateway for me to actually do it on a consistent basis. Cooking with my kids. Sailing with friends. Hearing strangers' stories and feeling no guilt because I wasn't sacrificing time with people I loved, supported, and cared about. Shedding the obsession with self-care, and applying my we-care mindset turned my rest into a love letter to my community of friends and family, which reinforced my desire to do it more. This provided the blueprint for how to rest in a more successful way.

Embracing harmony as the goal instead of balance was also a game changer. With harmony, two opposing ideas can exist at the same time and everything will still be all good. This is the hardest part for so many of us because we tell ourselves that if we rest, we can't solve our problems or challenges. But that's not true. You can be frustrated with your boss and still appreciate their leadership. You can adore your children and want to ring their necks at the same time. And yes, you can ebb and flow through stages of REST and WORK in your life and still get results that exceed expectations.

I'd love to tell you that I've kicked my workaholic tendencies to the curb, but let's be real—it's an ongoing recovery journey. The world is full of uncertainties, and my survival

instincts are always on high alert. But here's the thing: I don't want to keep hearing stories like mine—another woman in her forties succumbing to cancer, a heart attack, or worse. I'm craving stories of people not just surviving but thriving, a whole movement of folks sharing mind-blowing tales born out of hitting pause. We all deserve freedom, harmony, and full-bodied prosperity, and my ticket to claiming it started with chanting this truth whenever the fears of failure and demise threaten to swallow me whole. "There is power in my pause. There is power in my pause. There is power in my pause." So, join me, won't you? Close those eyes, let it roll off your tongue, and declare that you can pause your way to the life of your dreams.

Key Takeaways:

Rest isn't just a lavish indulgence; it's a vital ingredient for maintaining a steady course toward success without compromising your long-term goals. By embracing a permanent state of rest-first-centered leading that prioritizes pause in harmony with your ambitions, the apex of professional success will come easily. You'll never achieve the peaceful gains you want by working harder. The power has always been, and will always be in your pause.

Kibi Anderson

Kibi Anderson is a keynote speaker, coach, and Emmy Award Winning content producer. She is a graduate of Harvard College and NYU Stern Business School, and the founder of Life Editor, a firm that provides communications and leadership coaching to C-Suite & Senior Leaders.

She has helped drive millions of dollars in annual revenue, created international content campaigns, and offered counsel to global Fortune 100 and startup clients. She has traversed an illustrious career in international management consulting, film production, and technology entrepreneurship, while also managing a chronic auto-immune condition.

A life-altering conversation, which forced her to face the stark truth that her overworked lifestyle was going to kill her, was the catalyst to her current project, a book chronicling her journey back to 100% health, and to realizing that despite what society teaches, the key to ultimate professional success is not through working harder, but embracing the power in the pause.

https://kibianderson.com/

https://www.lifeeditor.co/

https://www.instagram.com/kibianderson/?hl=en

https://www.linkedin.com/in/kibianderson

4
In Their Shoes

Julie Candelon

Across the bay, the air vibrates with the energy of a thousand storms. Visibility? Almost zero. The fog is so thick I can slice it, so I'm left navigating with my instincts and a prayer, maybe. And let's talk about the currents and tides, those relentless forces trying to push me back against the Golden Gate Bridge, no matter how hard I try to resist. Add a sea of traffic with massive cargo ships not budging an inch to avoid thirty-foot sailboats such as mine. I feel small and vulnerable. And then, there is this not-so-secret ingredient: the San Francisco wind. It's fierce, it's challenging, it's unpredictable, but doesn't it make the adventure incredibly exciting?

"When you know how to sail in the Bay Area, you can sail anywhere in the world," they say. My first time sailing was on a cold, foggy, and windy day that kept my adrenaline levels through the roof. I couldn't help but wonder what I was doing there. Over time, I went from being this novice female sailor struggling to hoist the sail to becoming the best version of myself; strong, resilient, adaptable. A conqueror of life storms riding this wind with pure joy!

Funny enough, I find that working in the Bay Area is remarkably similar: wild, challenging, and exhilarating. Silicon Valley is like the grand stage of the world's fiercest talent show. It is not just a place but a baptism of fire, where the tech-savvy and the dreamers melt together to forge the future. Here, thriving is more than an opportunity, it's essential to swim in this ocean of brilliance. Otherwise, I could sink. And like in the water, visibility is a myth most days. I'm constantly charting to unknown territories, where the next big storm could throw me off course. The pace? A never-ending race. The environment? Constantly shifting, with companies blinking in and out of existence and seismic shifts shaking the ecosystem regularly. And then there are the captains of these tech vessels. Founders and leaders with minds as brilliant as the shiniest stars, though not always displaying the soft skills or emo-

tional quotient I hope for. Obviously, it does not apply to all of them, but enough to make my career an adventure in human understanding and strategic navigation. It's exhilarating and daunting, all at once.

So, yes, Silicon Valley has been my little heaven, my stormy sea, and my open sky, all rolled into one. It is what honed my skills, sharpened my instincts, and emboldened my spirit over the last decade as a fractional chief marketing officer (CMO) for some of the fastest-growing tech disruptors. Every day I learn to dance with ambiguity, embrace change like an old friend, and negotiate the turbulent personalities with grit. I'm addicted to learning and experimenting. And it has never been truer than today with AI shifting everything at a speed I have never seen before. I can hear it everywhere: "It's not AI that is going to take your job, but someone who knows how to use AI might." In this ever-changing world of marketing and tech, staying still is the same as moving backward. And like with sailing, I am convinced that my experience here in the Bay Area makes me stronger and more equipped than most to survive and thrive in any business situations anywhere in the world.

Working as a fractional CMO, I'm guiding and scaling between three and five companies at any given time. I'm a

marketing executive on steroids! One day I'm brainstorming with a CEO on the best way to pivot, the next I'm guiding eager employees through the marketing maze. I accumulate experiences the same way I would assemble a vast and intricate marketing puzzle. Some pieces are trickier, requiring time and patience to find their rightful place. They represent the periods of struggle and learning. And as the puzzle grows, a coherent picture emerges, one that's rich with complexity and beauty. It is never truly complete though. There are always more pieces to add, more experiences to gather.

And I would be crazy not to beg for more. I'm successfully wearing enough hats that it feels like I've lived ten different careers in one. "Julie, can you do this?" and "Julie, are you available for that?" I have a hard time saying no and, even though I'm sometimes spread a little thin, this journey is a bliss I'm privileged to live. But let's keep it real, it wasn't always smooth sailing. There were moments so gigantic in their intensity and insanity that they put me at risk. They reshaped my path, teaching me the value of taking care of myself and leaping into the unknown.

Over the past decade, my journey through the heart of Silicon Valley has equipped me with an unparalleled depth of experiences and insights, making me uniquely qualified

to guide others to success. Whether it is navigating the complex corporate ladder, mastering the art of impactful marketing, or leading as a visionary founder, I can help.

With all these insights and experiences accumulated, I decided a few years ago that I had to build a legacy, not simply a career. However, I can only work with five companies, maximum, at any given time. So I've also become a mentor, a limited partner, and an advisor. It's a way for me to extend my reach and the impact I can have. Part of my power lies in successfully implementing changes to unlock business growth and scale. But it also comes from sharing my journey, passing the torch, and mentoring others to spot and bridge the gaps in their paths. I take an immense pleasure in lifting others up to be not only successful but legendary.

This is why, as one of my side activities, I began having regular conversations with graduate students from the entrepreneurship master program at the University of California, Berkeley. Every year, I meet them a few times throughout the program.

"What are the latest marketing trends I should know about?"

"What career opportunities do you see?"

"Any tips to find a job?"

"Can I pitch my startup to you for feedback?"

"What do you think of our go-to-market strategy?"

It's always fun to hear their many questions and learn about what they are doing. It honestly feels as if I gain as much as I give. And this school year, the cohort of students is a bit different. More mature and more ambitious than the previous ones, if that is even possible.

So there I was this past fall, locked in this moment with James, a Berkeley student quizzing me with a mix of anxiety and ambition. His question cut deeper than just the usual student worries. He wasn't fretting about blending into the workforce. No, his concern was much sharper.

"How do I make my mark from day one, when my resume reads 'inexperienced' in bold letters? How do I shine in my manager's eyes, especially given how green I am?" he asked, making it clear that he was seeking more than a job, but a launchpad for greatness.

This was his challenge to me, a weakness he was determined to address even before setting foot on the starting block.

Guiding and mentoring young professionals through their early careers, dreams, and ambitions, I've fielded many questions. Yet, this one resonated with a clarity and awareness not often seen. I see it as a testament to this generation's struggle to find their footing in a workforce that values experience over potential.

The generational gap is felt more and more every day at work and we can't keep ignoring it much longer. The younger workforce is ready for an honest and human discussion about designing work and life to maximize meaning, purpose, and impact. They are also the ones struggling the most with staying engaged at work. "Why would I work so hard for you?" they ask. "My company is not my family," they say, while quiet-quitting headlines are everywhere in the press. Many prefer a gig-worker mindset which has emerged since the pandemic. They are detached emotionally from the organization, while the Boomers value dedication and loyalty. Gallup's latest data shows that since March 2020, the percentage of highly engaged Baby Boomers has increased from 34% to 36% at work, while every other generation's went down.

In this context, this student's question was pure gold. It showed me how exceptional James was already by signaling his readiness to bridge that gap. He was not only looking to

be seen but to shine, to transform perceived inexperience into undeniable value. He wanted to understand other generations to maximize his chances. Brilliant!

I immediately thought of my own expectations when managing interns and fresh talent stepping through my doors. My guiding principles appeared clearly. The minimum required to succeed as my direct report in this fast world of tech?

"Don't be one more problem in my life because I don't have any time for that!" I said. "Bring your A-game every day; be reliable, curious, and efficient. When I share a task, I'm not delegating work, I'm entrusting you with a piece of our collective dream, so you'd better be taking notes," I added. "When you catch that ball, run with it. Be punctual, be prepared, and above all, be present and communicate. If there's something you don't grasp, step forward, questions in hand. Don't stand there facing a wall, waiting for it to go away miraculously, but look for ways to get around it."

Your initiative to seek clarity, to bridge those gaps without adding to the pile of challenges we navigate daily, that's a victory in itself. "If you can do that for me, as your

manager, I'll spend as much time as I can teaching you and taking your career to the next level."

It's this proactive spirit, this readiness to embrace challenges without being asked, that sets the true trailblazers apart in my mind. I don't care if you are ticking off tasks, it's about you being a cornerstone of support where it matters, a reliable force that propels us forward. I want to know that when something lands in your hands, I can trust you with it and consider it off my list, even if it requires some help here and there. As we say around here, it's all about the execution. I have repeated the same exact motto to each of my teams over the years: "Be bold, own your sh*t, and get it done." And yes, you caught me swearing. Did I forget to mention I am French? In all seriousness, this motto summarizes everything I expect from a winning team. Dare to do things differently if you don't want to keep seeing the same results. Be fully responsible for what you're working on and your mistakes. And more importantly, be proactive at every step, driving your projects to full completion.

At first, I was quite pleased with the answer I had given James. Yet, pretty quickly, it felt like I had given him the bare minimum. My mind raced back through the archives of my own story, the highs and lows, the moments of

doubt and breakthroughs. When did I see the biggest growth in my career and why? What were the game-changer conversations I had?

I remembered. Very early in my career, one of the biggest "aha!" moments hit me in the face. I mastered the art of selling everything but realized I skipped the most crucial lesson, how to market myself. It's one of those ironic twists of fate that as marketers, we become wizards at showcasing the sparkle of products or brands we represent, yet, when it comes to putting our own shine on display, we're left fumbling in the dark. The realization was both a wake-up call and a stepping stone. Understanding my value, my unique contributions to the table, wasn't only an exercise in self-promotion. It was about aligning with my core, my ethos, and radiating that confidence outward.

However, my most significant growth occurred several years later, and my career took a major turn because of it. Exchanging ideas with a CEO, a new realization dawned on me. There's a deeper, more nuanced layer to selling oneself. It's not solely about the pitch, it's about the high-stakes conversations.

"How can I articulate the value of my work, especially when it doesn't directly align with the immediate priorities of leadership?" I asked.

"It's about bridging worlds, about translating your passion and projects into a language that resonates with everyone in the leadership team," the CEO replied. "Marketing is not their thing. You should make them see not just your work, but its impact through a lens they value."

Strategic empathy at work! That was the magic bullet that changed everything for me.

When I think about it, empathy was always a core value of mine, something I looked for in any leader I deemed worthy of engaging with. Why? Most likely a combination of my childhood upbringing and that one co-founder who had left such a painful scar many years ago. As a pervert narcissist, he was fully aware of his own greatness and completely lacking in empathy for others. While constantly trying to seduce everyone like a chameleon with multiple faces, it seemed like he felt exposed in my presence, maybe threatened by my area of expertise, and his mask fell quickly. He became extremely toxic, and for more than a year, I was relentlessly pushed to my emotional limits without mercy. I remember comparing meetings

to torture sessions, feeling like I was silently brought to my knees. It took me months to recover, and since then, the complete absence of empathy in bright and innovative minds is a gigantic red flag for me. I keep my distance as much as possible and take boundaries more seriously to avoid getting too close to my emotional limits again. At the opposite end of it, I have the most profound admiration for influential CEOs who demonstrate empathy and make it clear that they prioritize their people.

So when that CEO offered me his advice on how to be more influential with other leaders using empathy, it didn't take much to convince me. I followed his advice religiously, reflecting on ways to articulate my value through their lens. I started fine-tuning my approach and absorbing feedback on how I presented the marketing team's projects and achievements to all leaders. It was a lesson in perspective-taking, realizing that to truly engage, I needed to step into their shoes, to see the world through each of their personal goals and priorities.

Empathy became my compass, not just to navigate my life, but to get through the turbulent and competitive seas of Silicon Valley, and to emerge transcended.

One of the simplest yet transformative pieces of advice I received from a mentor soon after was on revamping a PowerPoint slide presenting campaign results. "There is power in leading with the outcomes and learnings first. Focus on the bigger picture and the main message you want to imprint on the executives' minds and put it directly in the slide title." This approach offered them a choice. They could "dive deeper if intrigued or walk away with the essence, because their time is a currency too precious to spend on matters they don't directly influence." It underscored a vital lesson: everyone's focus is on growth, pipeline, and revenue—the core of the business. "Stop trying to bring them into your world." The intricate details of marketing, while captivating in my eyes and crucial to influence the business, are secondary in the world of tech leaders. It's not so much about the "what" but the "so what," connecting our work to the overarching goals that drive the company forward. If I can show each leader how I can make them successful in their job, then I can win them over systematically.

"Don't scare them with the details," the CEO reminded me shortly afterwards as we were getting ready to present a major change management plan. You might find all this quite obvious, but at this stage in my career, it

was a constant fight to go against my instincts. My focus on educating and over-communicating was diluting my message, and my natural inclination to get to the details kept resurfacing.

A few months later, as I was trying to reshape the marketing team and guide them to success, I had this conversation with the CEO. We were brainstorming on how to create the right company culture and environment when he confided in me and shared his own twist of irony: "Stepping into the office kitchen, a space of my very own creation, has turned into my personal *Twilight Zone.*" The idea of mingling and making small talk with the team? "A nightmare scenario for me. I can't stand the idea of losing my time with small talk. That's why I always have lunch in my office."

I was a bit shocked. How could he not want to connect with his teams and get to know them better? This got me pondering, how do we bridge that gap? How do we connect with leaders like him, for whom casual banter feels like walking a plank? A month later, caught in an elevator ride, sandwiched between meetings, my mind racing through the to-do list, I found myself echoing the CEO. As a business owner and a single mom alone in a foreign country, time was the only meaningful currency in my life,

and every single minute mattered. I knew precisely how much an hour of my time was worth, and everything was measured against that: "Is this thing requiring my attention actually worth the price? Isn't there something more valuable to do for the next five minutes I have?" Efficiency and impact were all I cared about then so here I was, in this elevator, craving efficient interaction, a dive into the next projects rather than skimming the surface with small talk. Yet, to my team, this was their moment to breathe and share something light and human.

In hindsight, that impatience, that frustration at what I deemed "missed opportunities," mirrored my own battle with time and stress. Back then, losing a few minutes to stop at a gas station gave me anxiety! I was certainly way too close to burning out, but that episode was an eye-opener. Leaders are often perched on a tightrope of responsibilities, with every minute a precious gem. Recognizing this, showing that you get it, that you value these snippets of time as much as they do, that's where true connection begins. It's a dance of empathy, of understanding that their time, like yours, is precious. And respecting that? That's not just cool, it's paramount. I'm not saying that small talk is never an option, but understanding when it is one or not is primordial. That's the art of meaningful connection,

making the most of those fleeting moments to show you're not yet another face in the crowd, but someone who truly gets it.

Only after fully mastering the art of empathy at work and consistently showing up with that angle did I truly earn my seat at the leadership table. After that, I gained everyone's trust and respect by sharing meaningful business results in a way everyone could digest and relate to. My collaborations across departments became much easier. My efforts to adopt change throughout the organization finally became successful. I reached another level in the game.

That's what I tried to share with James at Berkeley this past fall. "Try to identify what matters to your manager, put yourself in their shoes to help them better, make their life easier, make them more successful. Go beyond not being the problem. Understand them, and be the solution."

Strategically relying on empathy is not only beneficial when looking up the ladder, it is a key component of any modern manager's toolbox. Beyond addressing the generational gap and lack of engagement mentioned earlier, I have found empathy to be instrumental in dealing with unexpected situations. Navigating the storm of Covid as a leader, I tried to understand what my teams were in

dire need of from a professional and mental standpoint. We had open conversations to identify pressure points and solve them. For example, after a couple of months in isolation, I found a simple way to keep our team's spirit positive and interconnected. Every day, thirty minutes were blocked on my calendar and my kitchen transformed into a Zoom stage for what I dubbed the "lunchtime open office." No pressure, just an open invite for anyone on the team to drop in, witness my culinary adventures, and share a slice of their day, their projects progress, or even the deep cuts of personal life, all while I prepared my lunch.

It wasn't about keeping the work engine humming. It was about recreating those spontaneous connections that light up office life, those kitchen counter conversations over coffee that we were all missing. It was especially crucial, given that one of my teams was assembled during the height of the pandemic, never having the chance to mingle, to connect beyond the back-to-back Zoom meetings.

We quickly took it a step further, dedicating sessions to purely non-work chit-chat, sharing our hobbies, travel stories, and our lives outside of work. There were many laughs and tears in these lunches, that's how I knew they were needed. This eclectic crew, with their diverse roles and visions, began to weave together, understanding and

valuing each other on a whole new level. That's the kind of alchemy that turns a group of individuals into a power-house team.

Empathy for managers? Check. For direct reports? Check. And what about clients?

Last month, another Berkeley student worked with me on refining his startup pitch. As we discussed his startup's journey, he shared the twists and turns, and the assumptions he made that now make him chuckle. He poured his soul into building a solution he believed was the next big thing, only to discover the hard truth too late. His dream product was chasing a ghost market.

"I lost so much time and energy. I'm never making that same mistake again!" he said. He flipped the script now, engaging with his target audience right from the get-go before building anything. A move so basic yet overlooked by many. It's a tale as old as time in the startup world, where the rush of creation eclipses the voice of the market.

I regularly meet tech-savvy founders engulfed in their vision. Too often they forget that once they step into those entrepreneurial shoes, they're no longer the customer. I often hear things along the lines of "I can't stand emails, so I'm sure no other engineer will read them. Email market-

ing will never work to generate leads in our market." Assuming personal preferences mirror the market's needs is a classic faux pas. Yet, conversations with potential users are usually dodged, viewed more as a chore than the goldmine they truly are. Those authentic, eye-opening interviews are the only way to step into the shoes of a target market. Y Combinator, a famous accelerator in the Valley, often says, "Talk to your users throughout the lifetime of the company." If I keep touching base with my audience and challenge assumptions one by one, then maybe I'll avoid costly mistakes. No CMO, actually no leader, should ever lose that direct line to their audience in my opinion.

But embracing the discomfort and fear of rejection is not simple. I get it; I was there early in my career as a product manager, dreading the prospect of picking up the phone and getting ignored daily. But trust me, it's a pivot that paid dividends. Week after week, I found myself on a quest, reaching out to potential customers, diving into what makes them tick, their needs, their pain points, and those "aha!" moments that could be the golden ticket for my product ideas. Airbnb and other major startup successes were born out of empathy efforts like these. The process, which is identifying the thoughts and feelings of customers at every step of the journey, is even called

empathy mapping. There's something irreplaceable about hearing it straight from the source. The words they use unlock priceless insights to craft products and messages that not only speak to the audience but sing to them. I am furiously taking notes when having these conversations.

I remember helping my young son develop his sense of empathy. I was always challenging him to identify signs of emotions in others, imagining how they felt based on his own experiences, noticing any breadcrumbs to better understand what they were going through in various situations, and ultimately asking questions to get to their own truth. That's exactly how to conduct these interviews. The words prospects and customers use matter, their facial expressions and what they choose to highlight are critical clues. The questions you ask and how little bias they contain are how you can truly learn and step into people's shoes. There is no better way to flex your empathy muscle. Empathy isn't a buzzword, it's my north star, and there's no shortcut to true understanding than by living in the shoes of those I serve.

Infusing my professional life with empathy isn't just about being nice or about including everyone's feelings in my decisions without limits. Of course, I care. But it is a power move too. It shifts the way I lead, manage change, and

spark innovation. It's how I create spaces where everyone is in sync, where ideas bubble up from a culture of real talk and mutual respect. I can only drive change and provide a new perspective if I understand yours. This is the secret sauce to lighting up achievements, making waves that ripple through my teams and touch the hearts of those we serve.

Remember how back in the day, sealing deals was all about sharing experiences? That hasn't changed. Aren't sales folks still wining and dining clients, hitting the golf course, or diving into those lavish, laughter-filled adventures? It's how they forge that bond, the "I get you" vibe that transcends the transactional. And no wonder why everyone loves Jake from State Farm or Flo from Progressive. They are here to create that individual connection, that personal touch that makes big corporations appear more human. As a captain on my ship, I've learned the importance of showing to my crew that I am authentic, competent, and empathetic. I care deeply about them and their safety. That's how I build the critical trust I need when we face the biggest storms and unexpected challenges. When clients stick with us because of the empathy and the trust we built, not just the contract, that's when I know we've hit the

jackpot. Because it's these human touches, these shared smiles and stories, that build empires.

Key Takeaways:

By inserting empathy into your career and business strategy, you unlock the door to deeper connections, transformative leadership, and groundbreaking innovation. You become more attuned to the needs and aspirations of those around you, from managers to team members and clients, nurturing an environment of collaboration and heightened satisfaction. Embrace empathy as your secret weapon, and watch as it sets you apart and propels you to unparalleled heights of success.

Julie Candelon

J ulie Candelon is a B2B marketing expert, business owner, and Silicon Valley veteran.

She is a fractional Chief Marketing Officer, board director, advisor, and mentor who empowers tech entrepreneurs and leaders to accelerate revenue growth globally.

Her unique perspective, data-driven marketing approach, and result-focused leadership have earned Julie opportunities to serve prominent venture-backed startups and Fortune 500 companies, including NVidia, Amazon, RingCentral, Cumulus Networks, or EditShare....

When she's not sailing in the Bay Area or traveling the world with her son, Julie enjoys dancing, photography, and exploring innovation, AI, or startup investing. She is

also a best-selling author, passionate about empowering women to succeed in Silicon Valley.

www.jmarketing.team

www.linkedin.com/in/jcandelon/

5
Embrace Your Superpowers

Carol Wheeler

"Let's go look at it today!"

My heart skipped a beat as I replied, "Now?"

It was one of those November-in-Texas days, crisp, cool air with bright sunshine, as a friend and I drove back from lunch. We passed a building that had been for sale for a while, a huge old house turned into a business. "Someday I would like to buy a building like that one and create a shared office space," I said as I pointed to it. In my mind, this was a "someday" dream, not a "today" dream. But the

next morning I found myself standing inside that building with my friend and a realtor, checking out the space. The wheels were set in motion, and there was no turning back. Some might call this impulsive, but I've learned through the years to trust my first instinct and see where the path leads. One of my unique talents is to see the end result in full color and definition before I can articulate the path to that result. Trusting this superpower has served me well on multiple occasions.

As I walked through the door, my mind immediately created a picture of the future lobby. I could see right where the chairs would go, the light from the transom window above the door shining down into the space. Each space that would become an office was clearly laid out in my mind, along with the modern-but-historic-looking light fixtures we would install. I could see how we would rearrange the kitchen area to make it a gathering place, and I could hear the conversations that would take place there. They were there with me, the entrepreneurs who would occupy the space, drinking coffee, and sharing their dreams and struggles. My excitement grew as we toured the space. Moving forward was the only option.

I had a nest egg set aside from selling my dad's business and dreamed, for a while, of investing it in commercial

real estate. As a member of the local business community, I knew firsthand how many entrepreneurs wanted office space, but couldn't afford their own building or large space. Community and connection have always been drivers for me, and I dreamed of opening a shared office space where entrepreneurs could come together, have their own professional work space, but also get to know and support each other. I live in a thriving small town with German heritage, so I started looking for a German name. When I stumbled on *sammelplatz* I knew I had it—the word refers to the town square, or "gathering place," in a community. As the vision grew, I started telling everyone who would listen to watch out—in five years when you said the word Sammelplatz, the local business community would say, "Yes, I know that building, everyone who offices there is a pillar of this community."

That's when the work really began—I had never done something like this before, but I knew I needed a business plan. My brain works in numbers, so I started with a spreadsheet. A contractor friend met me there a few days later, and we began the process of determining what the renovation would look like and how much it would cost. A flurry of activity followed, making calls and doing web searches to estimate utilities, insurance, taxes, and what to

charge in rent. I mapped out scenario after scenario, considering various coworking and shared office space ideas. My vision was clear from the beginning, although it took some time to articulate.

Sammelplatz would be a gathering place for entrepreneurs, a workspace where small businesses could rent an office and have access to a professional space complete with a conference room, beautiful lobby, and a shared kitchen. It would also be a place for those entrepreneurs to support each other and our community. This vision drove me. Once I had it in writing, I couldn't stop. In this small, but quickly growing community between Austin and San Antonio, Texas, the need for this type of space was so clear, I knew I could make this vision a reality.

You may be wondering at this point how I knew what to do next. I had certainly never done this before. Looking back, I can trace every step I took to experiences from my past where I had learned some piece of what to do. In the midst of it, I didn't overthink it—I never once thought I knew what I was doing overall, but I always seemed to know the next right step. Now I know my zone of genius is trusting my intuition and taking the next step without always worrying about what happens three steps down the line. "Zone of genius" is a term used by author Gay

Hendricks to describe working on your peak performance zone, where you are doing things only you can do. This is where you embrace your superpowers, leaning in to those talents and abilities that are truly unique to you.

Next came my first meeting with my loan officer. My friend Lisa works at a business-friendly local bank and set up the meeting. Walking into the restaurant that day, I was nervous. Lisa had given me the scoop on Robert, so I knew he had been doing this a long time and was pretty no-nonsense. Generally, I prefer to work with other women, both because I love supporting other women in business and because I find other women more often open to true partnership. I felt like an absolute newbie as I shared my vision with Robert. He began asking questions about the numbers, and I realized pretty fast I still had some work to do. Still, I knew the answers to *most* of his questions, and could confidently say I knew how to find out the answers to everything else. Turned out Robert was the best kind of loan officer—he believed in me and my vision. He somehow knew that I could figure out anything I didn't know yet and mentored me through some tricky numbers without ever once making me feel inadequate.

Armed with a vision, a business plan, and a loan commitment, I made an offer on my dream building. The day

I made the offer, I was on a huge high—it all seemed a foregone conclusion. Sure, we had offered a little low, but the building had been for sale for a long time, and we were willing to negotiate. I signed the offer letter and had a celebratory lunch with my realtor—I was about to buy my building. Then we waited. And waited. When we finally heard back three days later the answer was simply "no." No counter-offer, no feedback, just "no."

I was devastated and confused. If you've ever bought real estate, you know it's pretty unusual to not get a counteroffer of any sort. After a strategy session with my realtor and loan officer, we went back with a higher offer. I wrote the sellers a letter telling them about my vision and how I wanted to breathe new life into the building because it's such an important part of our local community. After making us wait a week, they came back again with "no."

Nobody who knows me will be too surprised to hear that I cried that day. My dream came alive, and now it felt dead. Two months of work for naught. It made no sense to pay one dollar more than we had offered for that building, and so I walked away. My intuition and the numbers agreed, and I knew that if there was no negotiating the price, it wasn't the right building. But my entire vision was built

around that building, the feeling of it, the location, the history!

It took me about a week to realize I was wrong. That building wasn't the vision. The Sammelplatz Community was the vision. I didn't need that building, but I did need a building to make my vision a reality. Three months later we closed on an equally perfect (but VERY different) building and started the renovation process.

As female business owners, when we run into obstacles, like the seller who didn't really want to sell, we tend to go to the negative. We revert back to the stories about the worst of us, which often look like the ways we were told to be smaller when we were younger. This is definitely true for me. When things go wrong, I can easily start dwelling on what might be wrong with me that is causing the issue. Deep down, though, a part of me has always known this is a false narrative. This internal strength shows itself most when others start to question my abilities.

When I started second-guessing myself about the building, my story went to how I have my head in the clouds, too many big ideas that maybe aren't realistic. *And why did I go and talk about it so much, and now it's not even going to happen?* Growing up, I was often told I talked too much,

shared more than was necessary, and wasn't realistic. One such interaction occurred right before the start of seventh grade. That summer I spent a month at a girls' camp in the Texas Hill Country, sleeping in a screened-in cabinet without air conditioning. Let me tell you, it was HOT! Prior to that summer I avoided sweating if at all possible and had refused all my parents' efforts to involve me in sports. Coming home from camp, I was so excited to tell my mom about my new dream—to join the tennis team. I envisioned how excited she would be since I finally found a sport I liked. My happy balloon deflated with her dismissive response, "You'll never make the tennis team, you don't like to be outside." I was heartbroken but undeterred. Turns out that the same part of me that talks and dreams too much also actually believes in those dreams and is willing to go for them. That's my superpower. I made the tennis team, played all through high school, and was number one on the team by my senior year. Don't ever tell me I can't follow my big dreams.

In my consulting business, I conduct a lot of workshops using CliftonStrengths, and we really lean into what is great about each person. CliftonStrengths is a psychological assessment that helps individuals discover and understand their natural talents and strengths. The assessment

identifies a person's top strengths out of a list of thirty-four themes, such as Achiever, Relator, Strategic, and Learner, among others. It is based on positive psychology and emphasizes focusing on strengths rather than weaknesses. Not long ago in one of those workshops, a woman looked me dead in the eye and said, "Carol, this says that I am intense and compare myself to others. I've been told my whole life that is what is wrong with me, so how can you say it's a strength?"

Those things aren't just her strengths, they are her SUPERPOWER. Her competitive drive and intense focus drive her entire team to succeed and provide incredible energy to make big things happen. Unfortunately, her experience is not unusual. Most of us, particularly women, are told from a young age that the things that make us unique, the biggest parts of our personalities, make others uncomfortable, and we should keep them quiet and hidden. We are constantly given messages to be more like other people, to conform to the norm, rather than being told to be MORE of ourselves. To embrace my superpowers, I had to become MORE of me, not less. I had to embrace the fact that I make fast, intuitive decisions, and when I do, I almost always make the right decision. Embracing my superpowers also meant accepting that I

am significantly more motivated by relationships than I am by achievement, so linking my goals to relationships always serves me best.

One of my other superpowers is the ability to pivot. My number one strength according to CliftonStrengths is Strategic, which basically means my brain is constantly taking in new information and adjusting decisions accordingly.

This turned out to be incredibly beneficial during the renovation phase of Sammelplatz. Once we started demolition, it seemed like every week there was a new discovery—apparently the folks who had originally built this building had taken a few shortcuts. With each new discovery, my contractor would call and we'd make a decision on how to proceed. Others were often surprised at how comfortable I felt making construction-related decisions and in general with the whole process. While some of these perceptions might have been gender-related, I saw it more as a lack of knowledge of my experiences, and surprise on their part that I was quick to make decisions, period. Reflecting back, I can say that two experiences really contributed to this. First, I grew up with a contractor grandfather and was regularly on job sites. Second, my very first full-time job was being in charge of two residence halls, one of which

was under construction when I started. I had been hired to run the building when it was open, but until then I coordinated with contractors, checked punch lists, and learned a ton about construction. I worked a number of years in residence halls, where I was responsible not only for the residents but also for the maintenance of the building, key management, and coordinating housekeeping. I'll never forget the day before Sammelplatz opened, sitting at my new desk sorting office keys and labeling them to hand out to tenants. I had a visceral flashback to my days handing out keys to residents and laughed out loud at myself. It felt like my entire professional background had prepared me for this day.

Residence life also taught me a lot about community building—how to help people get to know each other and feel connected quickly, even when they come in with different backgrounds, different goals, and different futures. As we got closer to finishing construction on Sammelplatz, I started talking about curating a community. I put the word out that I had offices available to rent, but in every communication, I included my vision. Each interested tenant was asked to complete a form, including this question: "Sammelplatz Office Suites are designed to serve community-minded entrepreneurs who want to

contribute to New Braunfels and be a part of a group of office mates who gather, get to know each other, and support each other. What about this vision excites you and makes you want to be a part of it?"

A few days before we opened, I hosted a small gathering of all the new tenants and their families. We handed out keys but also took time to get to know each other and celebrate this new space. We arranged the furniture in the lobby to create an intentional gathering space. We made sure there was coffee and water available from day one for everyone in the building. And now we host monthly potlucks for everyone in the. These seemingly small things added together have created a community of people who not only love their physical office space but love connecting with and supporting each other, inside and outside of the building.

I never sat down and wrote out a plan for how I was going to build community at Sammelplatz, but every step I took was pointed in that direction. Connecting people is something that comes naturally to me and a talent I have honed over my career. The first training I went to about building community was back in 1992 when I became a Resident Advisor in college. Since then I have been through innumerable trainings and classes on understanding and lead-

ing people, as well as teaching them. I built teams that felt like family. In every job I've ever had, sans one, bringing people together was the focus.

That one job taught me a lot about myself, and what happens when I'm NOT in my zone of genius. I was still teaching a few classes, but the largest part of that job was mentoring individual students in research. Looking back, I can honestly say that, while I was pretty good at the job, I was never great. And the longer I did it, the worse I got. I didn't enjoy it, didn't get that kick you get when you are doing something you are great at and feel like you are really contributing. I remember sitting at the table in my office with a student, listening to them talk about their research, and having to scold myself inside my head to pay attention. My motivation went down with every passing year, and I started to really focus on my weaknesses. I would talk to myself about what I was doing wrong, and how I needed to improve my ability to proofread research papers, coach students on statistics, and help them present their research in the required format. Just typing it makes me feel sad. When we put ourselves in a situation where we are regularly working outside our zone of genius, we often land in mediocrity and boredom. We try to fix the problem by fixing our weaknesses. I began to think it was

me, maybe things had changed, and I just wasn't going to have a career where I did great things anymore. I wish I realized more quickly the answer was not to fix myself but to put myself in an environment where my superpowers were needed and valued.

Leaving that job and going full-time in my consulting business quickly renewed my confidence and had me back in my zone of genius. If I had not done that, I would have never had the confidence to pursue my dream of owning a commercial office space.

Two years later, I cannot imagine what life would be like if I hadn't taken that first step that day and called the realtor to go look at a commercial space. Every day, I go to work in a beautiful space with an incredible community of entrepreneurs. I dream about the next building I will renovate and the next community I will create. And as absolutely fabulous as Sammelplatz is, I know the best is yet to come. I will keep honing my strengths and becoming more of who I am, not less.

Key Takeaways:

Your past contains hints to your brilliant future. Find your zone of genius, your superpowers, and lean hard into it. You have talents and abilities unique only to you, and

when you leverage those things and ignore the rest, you have the opportunity to make the greatest impact.

Carol Wheeler

Most leaders struggle to get the best out of their people and creatively solve problems within a team. Carol provides leadership training and coaching so you can enjoy more team commitment and collaboration and less conflict at work. As a Gallup Certified Strengths Coach, Carol loves to help teams discover and deploy their individual and team strengths. She provides workshops and speeches on talent, emotional intelligence, conflict management, and building effective teams.

Carol holds a Ph.D. in leadership education from Oklahoma State University, a Masters in higher education and student affairs from Indiana University and a Bachelors in leadership development from Texas A&M University. She formed NopaLeadership to bring out the best in peo-

ple through empowered leadership so organizations can reach their objectives with the most important resource of all—people.

https://nopaleadership.com/

6
At All Costs

Stephanie Gitkin Hawk

Can a numbered list spell burnout? Staring at the laptop with burning eyes, my head pounds and my heart beats nearly out of my chest. I glance around the small meeting room to see the other business owners deep in thought typing away, clearly not paralyzed by a self-inflicted mortifying reality.

"What is stopping you from achieving your company's goals?" the business coach asked at the annual corporate planning workshop.

Without even realizing my fingers were hitting keys, the first five obstacles appeared.

Limiting Beliefs

 1. Everything depends on me.

 2. I am responsible.

 3. I am tired.

 4. There's not enough of me to go around.

 5. I shouldn't rock the boat.

The cursor blinks, taunting me to finish the list. Strategic planning for the upcoming year, usually my favorite part of these workshops, smacks me in the face with a shocking reality check.

I am the problem.

I've given every piece of myself until there was nothing left to give. Again. I've worked to prove myself at all costs and it ended up costing me dearly. *Why do I always fall into a pattern of stress and burnout? How did I get here?*

Another memory of exhaustion and shock thirty years earlier comes to mind. Struggling to keep my eyes open was the norm those days on the rare occasions I lifted my head from the sixty-plus hours-a-week work grind. My paternal grandmother sits on the passenger side of the car, her pearl

clip-on earrings dangling beneath silver hair coiffed just so. Perfectly painted fingernails tap lightly on the glossed coppertone of the reptile leather designer handbag. Comfortable in the silence, and more than content not to have to answer another round of questions about why I'm not married to a "nice Jewish boy," I drive past Jencraft's corporate office, the company started by my grandfather.

"Too bad none of the children are interested in the business." She breaks the silence with a sigh and a slight toss of her silver curls.

Wow. That cut deep. At twenty-four years old, I worked twice as hard for half the pay, BUT I was the wrong gender. What she meant was too bad neither of the *boys* are interested in the business.

It's impossible to separate my professional journey from my personal one. Perhaps it's that way for everyone. We are but one being. Our professional DNA is a carefully woven tapestry of personal values, academic learning, experiences, and relationships. "None of the children are interested in the business." Those few carelessly spoken words take root and spiral. They embed themselves like hot coals in my core, driving me to prove myself at all costs.

Did my father also want a boy to follow in his footsteps? He was a loving and proud father for the first six years of my life. After that, bit by bit, business stress seemingly ate him from the inside out. He traveled to Asia regularly and worked late when home. And let's just say we tiptoed around after we heard the door to the garage slam when he arrived home after a long day.

After college graduation, I felt ready to take on the world. The vision for my career path wasn't clear, but I had confidence in spades. Well, until my college party goggles cleared enough for me to realize that our country, shaken financially to the core by the collapse of the savings and loan industry and reeling from the Gulf War, was in a hiring freeze. Gulp.

Ultimately, my father "made me an offer I couldn't refuse." At least that's how I made it sound cool when he offered me an entry-level job opportunity at his company, a long-time importer and relatively new manufacturer of window coverings. Since this was my best (okay, only) opportunity, I jumped in to make the most of it. I truly felt that if I worked hard, I could be successful, be recognized and respected, and maybe, just maybe, be able to follow in his footsteps and run the company.

My father had no clue what to do with me when I started at Jencraft. How grown up I felt, though, carrying a mug of black coffee (which I was slowly learning to like) from the break room through the first floor of the office up to my tiny second-floor cubicle. The slightly musty smell, woven textured wallpaper, and rhythmic taps and dings from the secretaries' typewriters made the office feel the same as it had when I visited as a child. I found ways to make myself useful to the sales and marketing team by helping with marketing tasks and checking in-store product sets. When offered the opportunity, I gladly took on a new sales account in Canada that no one wanted, Aikenhead's Home Improvement Warehouse. I was eager for responsibilities and to learn everything I could about the business. In reality, I wanted to prove myself and earn the respect of my dad.

I worked side by side with the operational team in Toronto to set up our mini blinds and vertical blinds in the first store. The air was charged with the zing of startup energy and camaraderie. The excitement of becoming Canada's version of Home Depot was palpable. At the end of a long day, it wasn't uncommon to grab a drink with the bubbly redhead department head, Allison.

I also got to know the store manager, let's call him David, and would see him on occasion. One beautiful spring day, soon after the second Aikenhead's store opened, I roamed the aisles of the National Home Show at the convention center.

"Hey, David! What are you doing here?" I smiled in surprise when I saw him.

"I heard you were in town and came to say hello," he replied, then joined me as I walked the show.

"How about a beer and oysters?" he asked. "There's a great place nearby at the Harbourfront Center."

"Sounds like a plan."

I enjoyed David's company as we sat outside in the (thankfully) beautiful sunshine drinking beer and debating mid-Atlantic Blue Point oysters versus Canada's Alpine Bay oysters. He was probably twenty years older, but, in truth, the flirtation of the conversation was fun.

A few months later, I was invited to a party for the employees of his store. Bubbling with excitement and pride, I couldn't wait to tell my dad, hoping it would show how well things were going in developing the client relation-

ship. Sales were already strong, and it was obvious that the account was on a significant growth trajectory.

The travel expense was approved, and I jumped on the plane to rack up a few more Air Canada miles. After visiting the two stores that were open at that point, I headed to the bar where the party was in full force. I joined in the fun drinking Bloody Caesars (Canada's glorious version of a Bloody Mary), catching up with the team, and busting out my white girl dance moves (not quite as bad as Elaine in *Seinfeld* but definitely lacking rhythm). David was there, and things got flirty on the dance floor. Later in the evening, the ladies and I were in the washroom touching up lipstick and giggling about a few folks who had one too many.

"You know he's married, right?" Allison shared.

No, in fact, I did not know he was married. I thought I was a grownup savvy businesswoman doing my job well, but, no, I was being played.

"Yes, of course," I replied, hiding my shock. "We're just having fun dancing. Nothing more."

Over the next two years, I worked with the Aikenhead's Decor Department teams to open three more stores for a total of five in two years. It was exciting to be a part

of this Home Depot copycat startup and watch our window-covering product sales grow to over three million dollars. Home Depot took note of Aikenhead's success and bought them out to enter the Canadian market with a bang. Back at Jencraft, once Aikenheads became part of Home Depot, I was pushed aside as it was now a "House Account."

Frustrated but undeterred, I continued to find ways to get involved in different aspects of the business. I trailed around after anyone who would let me, and eventually, I pushed my way onto an operational team working to turn around the company's manufacturing plant in Reynosa, Mexico.

Day one, the plant was a disorganized mess. I looked around at partially produced pallets of mini blinds all over the place. How on earth could they figure out what they could assemble if they didn't know what materials and work in process were on hand? I grabbed the handle of one of the pallet jacks (which they called *mulas*) and encouraged the workers to help me start reorganizing and cleaning the 150,000-square-foot facility.

The young men, eyes popping out of their heads, said "No, Miss!" while reaching for the pallet jack handle. "Si. Estoy

bien. Vamanos!" I had a lot to learn at this point about working in another culture, but I wasn't going to stand by, point at what needed to be done, and watch like a *jefe*. This was the first step toward a massive plant reorganization and gaining the respect of the Mexican national workers, who adorably called me *Jefecita*.

It quickly became clear that the mess in the plant was a cause (and result of) poor raw material planning. Evidently, we kept running out of expensive pigments so we couldn't produce the right color extruded slats to assemble the end products needed. This then stopped the assembly lines partway through a run, causing expensive downtime and creating a maze of scattered work in process pallets around the manufacturing floor.

After direction and guidance from the general manager, who had a background in materials management, I worked day and night (literally pulling an all-nighter at the office) to create a multi-page spreadsheet using Lotus 123 (today's software options *would have blown my mind*). The new linked spreadsheets enabled us to input product forecasts by blind size and color to calculate pigments needed based on each plastic formula. This way we could order the appropriate quantities of pigment to keep the lines running. It worked!

Over the next six months, we were able to keep the production lines running, and there was no more tripping over half-assembled pallets of work-in-process. The next warehouse inventory was a hot, sweaty event as usual, but I nearly whooped out loud when the warehouse manager waved several zigzag pages of a dot matrix printout and reported. "Our on-hand finished product inventory is down $1,000,000 and order fulfillment is over 90%!"

I became indispensable over time, or so I thought until the day the general manager advised me that the promotion I anticipated for the materials manager job *I was already doing* had been given to a man "with more experience," at twice the salary. And would I please train him? I resigned the next day but then worked for seven months to train and transition. I gave everything I had until there was nothing left to give.

Being undervalued at Jencraft flamed the fire. I had something to prove and was grateful to find a general manager willing to take a shot on a young woman who was fired up and highly confident but only had experience in a family-owned business. Larry, a stand-up guy who unfortunately left shortly after I was hired, beamed as he handed me the prized white manager polo emblazoned with the

company logo. Larry blushed slightly as he apologized for the size of the polo, XL.

"We've never needed a smaller size. You're the first female in a management position here."

Taking the XL polo in hand, I wasn't deterred because I would make sure he didn't regret hiring me. I was brought on as a program manager but quickly moved up to advanced manufacturing manager. I wasn't an engineer and knew nothing about ISO or manufacturing processes but decided to "fake it 'till I make it" and dove in to learn. Management skills are management skills. Right?

My small engineering team quickly accepted me and gelled together well, but the middle-aged men who made up the rest of the management team kept their distance...until the birthday dinner. One of the managers was turning forty-five and the guys wanted to go out. They decided on TexMex Gentleman's Club with a smug look in my direction.

"Sounds good," I replied. "I'll see you there." And THAT was the turning point of my relationships with my male coworkers. Not my intelligence. Not my personality. Not the value I brought to the organization. Not even the fact that the improved bill of material accuracy and more effi-

cient processing of engineering changes kept THEIR lines running so they could hit THEIR numbers. The turning point was my *balls*.

I played the game, *their* game, even when it meant going to the strip club. Back at the office, I held my ground as needed to get the job done, resorting to a raised voice or colorful language to make sure the messages were received. In meetings, dressed in my imaginary big boy *chones*, I morphed into one of the guys, laughing at crude jokes, swearing, joining in on the sarcastic banter about Clinton's cigar, and ignoring the casual use of an anti-Semitic slur.

I sat in the new boss's office at some point in year two, trying to be cool and go with the flow. He stroked himself and told me how beautiful I was. At this moment, I felt anything but. But in a weird way, his words, focus, and arousal felt like approval.

"Don't you want to come here and kiss me?" he asked.

I declined, wishing I was anywhere else but believing that somehow I got myself into this situation. He was cute and one of the few guys I worked with who was close in age. Our friendship was relaxed and comfortable, work talk punctuated with sexy teasing and joking around.

"I'm a sex addict," he confessed over burgers one night, sharing details of his first sexual encounter with a much older woman when he was seventeen.

"My marriage is failing," he shared another night at the plant when we were working late.

"I dreamed about you."

"I can't stop thinking about you."

"Imagine how hot it would be if we..." The end of that sentence varied but was always shocking and titillating.

His climax sounded much like the voicemails he'd left me. It was a bad choice to let the lines get blurred outside of work a couple of times. But this? I get back to work feeling dirty and depressed.

For three years, I crossed the border from McAllen to be at the plant in Reynosa, Mexico, by 6:00 a.m., often staying until at least 7:00 p.m. Saturdays were spent pursuing my master's degree. I was on a mission to prove myself. *To whom*, I wonder now, *and why*? Once again, I gave everything I had until there was nothing left to give. Choosing a different path never occurred to me. The concept of choice seems obvious in retrospect, but at that point, I was

compelled to push myself to meet incredibly unreasonable expectations, expectations I inflicted upon myself.

And so it continued as the world around me prepared for Y2K, a new millennium, and potential apocalypse until the manic work came to a screeching stop with one phone call.

"It's amyotrophic lateral sclerosis, ALS," Dad said quietly over the phone.

Choosing to make a drastic change, which just the day before seemed incomprehensible, became a decision made without a second thought. I quit my job and moved back to the Northeast. Responsibility to family permeated every cell in my body. Priorities shifted instantaneously with the knowledge that this would be time I could never get back.

Images of the next year and a half are a slideshow in my mind. My dad's body deteriorated, but his sense of humor remained. His laugh...hearty and from the depths of his throat...whether from watching Adam Sandler's *Wedding Singer*, the counting of hanging chads, or his healthcare aide tripping over the wheelchair legs. Tender moments feeding him and seeing love and gratitude in his eyes.

Dad hung on to see me take my wedding vows as I married my boyfriend of two years (Naturally, someone I met through work.) My mother pushed the wheelchair down the aisle, and I followed behind, a strong breeze rippling my veil to the melodic waves of Pachelbel. A small but loving group of family and close friends watched with tearful smiles. It was a joyous moment. A new beginning and a final goodbye.

Loss is a punch to the core. When I reflect on all the time I wasted fighting to be seen and respected, it matters not at all. It was lost time. I was lost. My professional DNA was a knotted ball that choked the life out of my personal DNA.

The rollercoaster of life continued, as it always does. The highs of a honeymoon, the lows of a funeral, a move back to South Texas, and then the hope and pain seesaw of fertility treatments. When at last my son was born nine weeks early at three-and-a-half pounds, I knew I would never go back to the corporate world. There was no way I could leave him. Entrepreneurial blood ran as deep in my veins as my family values, and it was time to chart the course of the rest of my career on my own terms.

As an entrepreneur, I believed I could "have it all", and for the most part, I did, though, believe me when I say, not

gracefully. I bought a Learning Express store while pregnant with my second son. It was, in many ways, a magical time. I mean, what could be better than dressing up as Elmo and riding a plasma car around the store?!? My business partner (and bestie) was the yin to my yang. Her creativity, communication skills, and HUGE HEART helped soften the hard edges I developed over the years working in male-dominated environments. I nursed my baby in the back room while my four-year-old played with his favorite Thomas the Tank Engine train in the front of the store.

Retail under the best of circumstances is challenging, but we were downright unlucky. The cost of labor increased three times in two years, driving our costs and the cost of our products up significantly (compounded by the gasoline price spike, which drove up shipping costs). Oh, and the restaurant next to us had a break in a Coke machine line that flooded our store. Though we won the franchise's "Beating The Odds" award, after five years we had to accept it was time to say goodbye.

The timing coincided with my divorce, so I looked for an opportunity that would give me a new challenge, the ability to pay my bills, and the flexibility to be with my kids. I refused to go back to a traditional job and a sixty-hour workweek. Fortunately, I discovered digital marketing, the

perfect combination of creativity and numbers, and for the next six years juggled SEO sales and mommying.

What a time to be in digital marketing! The industry was evolving on a near-daily basis. From the birth of the iPad and local search to the boom of social media, web usage surpassed TV. Data could now be used in a rudimentary way to target users and content strategy was becoming critical. I felt strongly that agencies needed to adapt to a more integrated approach and co-founded Cobalt Digital Marketing to move in that direction. The company took off with year-over-year double-digit growth as we experimented with what we would ultimately call our Cobalt Formula™. We were a geo-diverse multicultural team of talent (that was before remote work was a thing), so I had the flexibility to be the mom I wanted to be for my boys. The pieces all came together as I integrated success at work with being true to myself. I was a present and engaged mom as well as an energetic business leader who wove community engagement into our corporate culture.

The strong growth trajectory of Cobalt continued throughout the Covid-19 pandemic as well as the following year as we worked with our clients to pivot and adapt to take advantage of online lead generation.

Like so many others, I learned that navigating a business through a pandemic while parenting teens is just as hard as it sounds. There was no beginning nor end to my workday. Cooped-up teens were as cranky as they were stinky. Work was an anchor through a time of uncertainty, yet, in the end, much as it did in my twenties, it pulled me down to a place where I lost sight of myself. While so many found sources of comfort in learning to knit or bake and maintained human connection through Zoom happy hours, I slid back into old habits. Driven by the need to do whatever it took to help our clients and hit record-breaking numbers for Cobalt Digital, I had no space, no boundaries, and no stress management.

The years 2020 and 2021 were one morphed blur, I thought as I stared once again at the partial list of limiting beliefs. I couldn't comprehend how I got to this place. Again. The numbered list clearly *did* spell burnout. I chose entrepreneurship so I could be the professional and mom I wanted to be, but, at this point, I felt like I was failing at both.

Before the workshop broke into smaller groups and, just in case I missed the very obvious point, the discussion shifted to the I'm Okay You're Okay matrix. A quick sketch went up on the whiteboard with the Y axis as respect for self and

the X axis as respect for others. Each quadrant measured the balance of I'm Okay versus You're Okay.

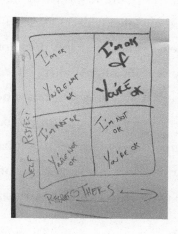

Blinking a few times, I slowly focused on this graphic depiction of my life. I'm not okay. *I'm not okay,* but I make sure that everyone around me is okay. By doing this, am I respecting others more than I respect myself? What a dumbfounding concept to one who has strived her entire life to be appreciated and respected.

It was time for me to evolve. This was going to take more than a surface behavioral change, this change needed to be a change to my metaphorical DNA.

A close friend suggested I listen to a Kate Anthony pod-cast entitled "Not My Fucking Job." It was specifically targeted at divorced women. Since I had been divorced for ten years at this point, it was particularly salient. The message pierced my intertwined DNA as I acknowledged that my deep sense of responsibility does not, in fact, make everything my actual responsibility. I needed clearly de-fined boundaries. What a shocking realization that it's not my job to pick up everyone else's dropped balls! It's not my job to overcompensate for, fix, bend over backward for, or carry the emotional load of everyone around me. It's not my job to live up to unreasonable expectations, even my own. Period.

From the beginning of my adult life, I was driven to do. And do and do and do to prove my value at all costs. But, as my list of limiting beliefs confirmed, I had lost my internal compass. One by one, I deleted each limiting belief and restated it as an empowering belief.

Empowering Beliefs

　　1. I own my journey.

　　2. I learn from mistakes.

　　3. I am always evolving to become the best possible

version of myself.

4. I define what success means to me.

5. I respect myself enough to create a life I love.

The weight of the old self-created paradigms lifted as I gained clarity on what I needed for myself. Asserting boundaries, though still immensely uncomfortable, is now my modus operandi at work (and at home). But I have redefined MY version of business success.

I stepped down as CEO at Cobalt Digital Marketing. Building creative strategies and using data to map and measure lead generation was enjoyable, but running a company, not so much.

At this point, I've come to understand that I want deeper meaning from how I invest my time. I founded VBI Strategies to bring business intelligence via visual data dashboards to nonprofit organizations. Knowing that every additional dollar I help bring in or more efficiently be used at Children's Advocacy Center of Hidalgo & Starr Counties, as an example, will benefit a sexually abused child or a young victim of sex trafficking, feels more gratifying than 100 Lamborghinis. This is me showing respect for the life I want to lead and the person I want to BE.

I can't hit the rewind button to BE the person who walked away from inappropriate relationships, behaviors, and situations. Or take a decade-long "mulligan" to reshuffle my priorities in my twenties. Suffice it to say, it would be glorious to revisit that time with a time machine to seek out a mentor, build quality professional and personal relationships, empower myself with boundaries, and make better decisions. I can't tell twenty-something me to have a vision for the person I want to BE and the life I want to lead. I can only BE proud of the person I am today and I protect her at all costs. The journey led me here and I'm playing by my rules!

Key Takeaways:

Own your journey. The only person you need to prove anything to is you. When you have this clarity and embrace your self-worth, you can align your career path with the person you want to be. Respect yourself with unequivocal parameters, and success will be yours!

Stephanie Gitkin Hawk

S tephanie Gitkin Hawk is an accomplished MBA executive with over 30 years experience in business development, international marketing, manufacturing, management, and retail. As co-founder of Cobalt Digital Marketing, a Certified Google Partner, she pioneered the Cobalt Formula™ for integrated marketing, delivering proven results across diverse industries. Stephanie's passion is to bring business intelligence tools to nonprofit organizations so they can maximize their resources and amplify results. As a Certified Dashboard Designer and Fractional Chief Results Officer, she has taken this passion to the next level with her latest venture, VBI Strategies.

Though she'll always consider herself a Jersey Girl, Stephanie has lived in South Texas since 1994. She's is a proud mom to two accomplished young men and a rescue bichon, Yuki. She loves spending downtime reading at the beach or pool, visiting wineries, watching Formula 1, and finding new activities to spark JOY.

https://www.linkedin.com/in/gitkinhawk/

https://www.facebook.com/VBIstrategies

7
The Drip

Laura Ramos James

"Dripping water hollows out stone, not through force but through persistence"
—Ovid

A massive limestone boulder, no less than six by eight feet, stands before me with an almost perfectly flat surface. Lush vegetation surrounds me with the sun peeking through the leaves. When I look back, it is hard to find the path I came from at this hidden gem of a hiking spot in Austin. The spring air is as crisp as can be. Upon closer look, the boulder reveals a hole of a few inches in depth on one of its corners. What could have caused such a

deformity? A blow from a sledgehammer? An earthquake? No way. The deformity is far too smooth to have been caused by an impact. What living creature or natural event could've had the strength to alter solid limestone in such a way?

Plip...plip...plip.... Absolute silence is disturbed by nothing but this sound. As soon as I think it'll stop, it comes again. Plip...plip...plip. It's just the slightest drop of fresh, clear water. It's so minute that I must get close to the source to see it. But there it is, a drop of water every couple of seconds. Plip...plip...plip.... Plip...plip...plip....

I kneel down and caress the circumference of the indentation. I can feel the curvature of it. It's slimy and a shade of brownish green. If I took a hammer to this stone and smashed it with all my force, I couldn't make a dent. Yet this tiny persistent drip of water has managed to mold the stone and form it to its will.

Reflecting on the power of that tiny droplet, I think of my own life as a mom, attorney, and business owner. Being constantly pulled in a million different directions, significant progress on any one front sometimes feels impossible. But like water dripping onto a stone, my persistence *plip plipping* over time, I make my mark. Discipline in business,

even in the form of what seems like small habits, tends to lead to success in the long run. And likewise, what seem like minimal disruptions, can alter the course of the progress we aim to make. Staying focused is crucial.

Consistency

I remember vividly the time I heard someone say that when you hang your shingle after working as an employee at a traditional law firm, you should continue having *at least* a standard working-hour schedule, like nine to five. The person who offered the advice (a successful business owner) said that if you did, you'd be guaranteed productivity and would avoid the risk of failing as a solo practitioner or small law firm owner.

In the months leading up to leaving a steady paycheck to open my own law firm, I wanted nothing more than to have a flexible schedule. I could not wait for those Fridays when I would get my yoga mat out in nature and meditate or go on incredible hikes. Or the random weekdays every so often when you'd find me in bed binging on Netflix just because *I'd earned it*. I was married but didn't have any kids at the time, so it was perfectly realistic to think I would do any of those things. I yearned for time to rest and reset. Yet, I was so excited to start my new adventure

that instead of taking any time off, I dove right in. Six years later, there have been no random weekdays of Netflix binging or Fridays in nature meditating. It is not for lack of desire to do any of those things. It is just that daily I'm doing something I enjoy way more.

Unintentionally, I ended up following the "*at least a nine-to-five*" advice. I keep a standard work schedule even though I don't have to. Late evenings and working weekends are frequent, but those are in addition to the regular business hours and not as a replacement for them. If anyone told me to pour that discipline into something I didn't enjoy, I simply wouldn't be able to do it while leading a happy and fulfilled life. It would not matter how much money could be made.

Similarly, what on the surface appears to be innocent interruptions, can lead to unnecessary detours and even derail plans and dreams. Like wind blowing on that constant drip of water, trying to change its course. There were over a handful of networking groups I joined when I started my law firm. Like so many who join these groups, I was hoping to get the word out about my business. I'd get to know other business owners, refer clients or customers to them, and they'd do the same. It all checks out so far. One of the specific groups required you to take a number of individ-

ual meetings with its members per week. That is in addi-
tion to the weekly group meeting and to any referrals you
get. My inexperience in this type of setting led to countless
unproductive and lengthy meetings with individuals who
did not care to get to know me or my law firm or how we
could mutually benefit our businesses, but rather wanted
to sell me a product or service. It stings to think what I
could now do with all the hour-and-a-half lunch meet-
ings spent being preached to about dietary supplements
or similar products. To be clear, the group is great, but I
was doing it wrong by taking *every* networking meeting,
instead of only the ones that were mutually beneficial for
our respective businesses. I try to stay positive and think
if one of those people gets injured in an accident one day
(although I certainly don't wish for it), they'll go through
their wallet remembering they'd met an injury lawyer once
who didn't buy their pills but whose business card they
must have kept somewhere....

When I left my last gig as someone's employee to start my
role as a law firm business owner and attorney, at the bot-
tom of my purse, you could always find a pocket notebook
where I wrote all the things. The first two pages had a
running list of everything that I needed to start my law firm
and keep it afloat. Things like "research best electronic fax

service" and "sign trust account documents and return by EOD" were part of that list. Every morning, I'd wake up with a fire within me, driving me to complete any tasks needed to make this dream come true. I woke up to complete projects and tasks when I was sick. When I had been up until the wee hours of the night working. When it was my birthday. When it was my wedding anniversary. When it was a beautiful day out. When it was raining outside. When I had an opposing counsel completely disrespect me and belittle my work the day before. When I lost a motion that I argued. When I was not paying myself anything. When I hadn't had a haircut or gone to the doctor in months. What kept me going was that I'd found something some people never find—I had found my calling. I was fortunate enough to do something I thoroughly enjoy and find meaningful for a living. Former University of Alabama football coach Nick Saban has said: "It's not really about what you want. It's about what you're willing to do to get it." Finding your purpose means you're willing to grind daily if that's what it takes.

Six years of discipline have contributed tremendously to the financial success of the law firm. According to motivational speaker Matthew Kelly, "Most people overestimate what they can do in a day, and underestimate what they

can do in a month. We overestimate what we can do in a year, and underestimate what we can accomplish in a decade." What started as me, a lawyer, with four cases and nothing but a laptop (no staff, no office, not even a filing cabinet) is now a eight-figure operation. But how I found the calling behind that operation is less than usual, and is in fact, tragic.

Passion

"Aww...she's so pretty! *But*, what happened to her?" the older woman's look of admiration quickly changes to visible sympathy. For our purposes, her name was Karen.

"Well, there was...we...umm, there was an accident," says my mom, nervous, straightening the hair on the side of my face with her fingers and pushing it behind my ear, then holding me tight by her side.

"A dog bit her little face, can you believe it? It took a portion of her nose off."

I had bandages on my face to show for it, so surely Karen could only imagine what was underneath them. I hated the bandages, but I had to wear them. Children learn to distinguish incredibly complex emotions and feelings by listening to their parents' voices as they speak when the

parents are experiencing the emotions. This was deep sorrow. Sorrow for me. I'm only three years old so I can't turn around and tell my mom "It's going to be okay. I'm going to be okay." I wish I could've done that, but I wasn't able to by any stretch of the imagination. It has taken decades upon decades—an entire lifetime of experiences—to get to a place where I can assure my mom that I *am* okay.

The very beginning of my quest for justice can be pinpointed to that specific encounter when Karen ran into us and offered a half-compliment during an awkward interaction: My mom, having to explain to a stranger our family's tragedy in the middle of the street, someone who was not really part of our lives at all and who we likely never saw again; me, with a voice and a million feelings about the whole situation but the inability to express them. I wanted to put to rest any implications that my parents were at fault before they even arose. An innocent three-year-old was not at fault for the attack, either. The dog owners were at fault, and no one else.

The encounter with Karen was not an isolated incident. Being a catastrophic dog attack victim permeated every aspect of my life for most of it. There were aspects of it that were visible to the outside world. Missing school due to having facial reconstructive surgery doesn't go unno-

ticed. The injury was in the middle of my face, and other little kids made sure I never forgot it was there. And there were also invisible aspects. Emotional pain and hurt that accompanies you throughout the day and that you should get used to and maybe become numb to, yet you do not. While the physical wound closes and scars, the emotional ones are wide open. There were also unanswered questions that caused anxiety: "Will I look this way forever? Will the scar ever go away? Will boys think I'm pretty? Will anyone ever love me?" My mom, dad, and sister have given me endless love my entire life, and each helped me heal tremendously in their own way.

In addition to that, being right about something, anything, felt like a warm compress on my achy heart. Studying and getting better grades than everyone showed me that I did not have to be pretty for people to like me. Thinking through situations, finding solutions, and voicing my opinion, especially when it had to do with defending someone, brought me closer to feeling healed. Much like having my own law firm now, recognizing injustices to stand up for and strategizing about how best to do that is something I enjoyed doing since I can remember.

Everyone wants to have stability and financial success, but few can commit to the sacrifices it takes to achieve it. Why?

Because the purpose that drives those sacrifices is missing. You have to find your passion in life first, your purpose, then let it fuel what comes next.

· · · · · · · · · ·

"There's no case there," my former boss said in a familiar tone that carried with it the implicit question of: *Why are you wasting my time? Let's call the client and decline to proceed. Or maybe, explain to me what exactly it is that you see that I don't.* Judging by his facial expression once I was done explaining, I could tell he thought something along the lines of: *Aw, my young associate needs my almost four decades of experience to discern a good case from a bad one, but I'll let her find out on her own.* The law firm kept the case, and when we parted ways, it was one of the four cases I made it a point to take with me. My then-boss had to have been so happy and relieved to get that case "off his books." But I can assure you he was even happier when I sent him a referral check after settling the case for six figures. This has been a common theme in my career. Cases that other attorneys would pass or give up on, I'd take and make the most of for my clients. I am certain I don't have magic powers, even though I tell my toddler I do. With well over a decade of legal experience, I've had success in cases that

many would call "losers," and the only explanation I can offer is that I care because I love what I do. An insurance company will undoubtedly pay more to an injured victim who can articulate at their deposition all the ways their life has been affected.

The traditional injury victim deposition (sworn testimony) goes something like this:

Defense attorney: "What injuries did you sustain due to the incident?"

Injury victim: "Both my wrists were fractured"

Defense attorney: "Are there things you could do before the incident that you can no longer do?"

Injury victim: "Mmm...no. It still hurts a little when I move my hands, but I'm basically fine now."

Defense attorney: (moves on to next topic).

Me questioning a client during her deposition: "Please describe for the jury the activities you were unable to do or complete as you were recovering from your injuries."

Injury victim: "I could not brush my teeth. I couldn't brush my hair. The most humiliating moment of my life is having my neighbor wipe my behind after having her help

me go to the bathroom because I could not do it myself. I couldn't sleep because of the pain, and I couldn't sleep because I was mortified about everything that I was going through."

It does not take a tragedy to find your passion, but "passion" definitely refers to a calling or vocation and not a hobby or interest. The drive within you should propel you to go the distance no matter what. Something deep down should be pushing those drops to drip constantly. Otherwise, it'll be nothing but a few drops of water that have no effect on a boulder.

To be able to help an injury victim dig deep, get the raw details out of them, and then gather the courage to speak up takes experience, practice, and patience. But most importantly, it takes passion. I've not been able to be consistent simply because I like earning money. I've not been able to "stick with it," rain or shine, because of the freedoms it affords me. It is only because I truly love what I do that discipline and hard work come naturally. There are a million and one jobs and ways to make money, to start a business, and to become someone very rich, if that is what you want, but if you choose something that is not a passion, you may not succeed. Why? When the unthinkable challenges come, when the rubber meets the road and you get put to

the test, you will be more likely to throw in the towel. If you're not thrilled about what you do, it is very hard to do it with little sleep and no pay, when other diverse lucrative opportunities may be tempting you.

· · · · · ● ● ● · · ·

Every night at our house, you can hear loud thuds coming from the second floor. Our baby is peacefully sleeping in her crib, and there's nothing but dim lights on throughout. The thuds are my three-year-old's incredible displays of athleticism as she does "somersaults" that consist of her half-rolling over and falling sideways on the floor. From the way her eyes glimmer and her smile goes from ear to ear, you can tell she loves it. This sparked a conversation with my husband on whether or not we should enroll her in gymnastics again this summer.

These days, parents are big on preparing their kids academically to enter pre-K, and from then on, the tutors and extra-curricular activities never stop again. As someone who always did great in school and took advantage of it to get financial opportunities such as scholarships, I always thought I would encourage my kids to push themselves to their maximum academic capability and get them all

the help to get them ahead. I no longer feel that way. It seems more consistent with my own life that I support my kids and cheer them on, guide them, and listen to them as much as I can. But with their best interests in mind as any parent, I want them to be happy, and in my eyes that means allowing them to discover their own passion, instead of dictating what that passion should be, what classes they should excel at, what college they should get into, etc.

Every parent will parent how they will. Having been allowed to choose what I wanted to do has made all the difference in my life. So, Victoria will do gymnastics for now, and if she gets tired of it and wants to try dance, we'll get her a tutu and do her hair in a bun. Is gymnastics my daughter's passion? It's probably too early to tell, but I recognize that many people (myself included) do find their passion early in life. Whatever Victoria's passion is as she gets older, we're committed to supporting her with it to give her the best chance we can at finding happiness.

Only true passion can drive sustainable consistency, the type of consistency that leads to success. There are a lot of other ingredients that give people an even greater chance of succeeding in business, and I believe preparation is one of those key ingredients.

Preparation

Just like the combination of a tiny drop of water and gravity bring about the drip, which in time wears on the surface it drips on, consistency only exists when passion and preparation coalesce. Even when you have found your calling and get to do that for a living, it is absolutely okay not to have all the answers. But we should never stop looking for the answers we need.

"Congratulations! What you have done is one of the bravest things any lawyer can do," Jason (fictionalized name) said. It was a lovely evening. With a rooftop view of the Capitol in Austin, the Texas Trial Lawyers' Headquarters hosted one of a handful of social events for attorney members of the organization. It was a well-attended event: The most prominent local attorneys, and state, federal, and municipal judges could be found among the attendees. A delicious spread of hors d'oeuvres and an open bar kept the hunger at bay and the conversations lively. To say I was uncomfortable was an understatement.

"To hang your own shingle! In twenty years of practice, I have learned that some months, there is nothing, no settlements, no income, and then you hit a big one and it makes up for it. Ebbs and flows!" Hearing an older, well-estab-

lished, and respected attorney say that was terrifying. Not for me, but for him. I could only imagine that like most of us lawyers, when he went out on his own, he thought he either knew it all or could find an answer, yet did not seem to have bothered to engage a professional to choose a profitable business model.

There are thousands of business consultants who could have helped Jason devise a plan to have a steady inflow of clients and revenue and minimize or eliminate the need to ever just wonder whether this month any funds would be coming to his law firm's checking account. And maybe Jason was joking or exaggerating, but, sadly, Jason is not the only attorney who has intimated the lack of business preparation when running his law practice. Over the years, a few others have shared how they had to take a job at someone else's law firm after their own failed attempt at opening their own firm. Upon further discussion, it usually becomes apparent that there was no business preparation other than the thought that having a law degree should magically translate into having a profitable law firm.

A law firm is nothing but a business, and as such, has quantifiable variables that can help an owner financially manage it like a business and keep it not just afloat, but

profitable. After all, as much as most attorneys go to law school to change the world for the better, many of us seem to ignore that a law firm is a business, and most law firms are for-profit businesses that need to be run as such. Yes, our jobs as attorneys and *esquires* are romanticized in novels and movies, and we have noble missions: We set the innocent free, we incarcerate the bad guys, we right wrongs. All true. Also true: Perry Mason needed to pay his rent, too.

My business consultant happens to split the bills with me under one roof and help raise our kids together. But even if I wasn't married to someone with a business and finance background, I like to think that I would've sought it out, recognizing that while I may be capable of delivering some killer closing arguments, I have zero business with an Excel spreadsheet. There have been times, especially at the beginning of Ramos James Law, PLLC, when the business could not afford certain costs like it can now. However, it could always afford the costs that were accounted for when I was *preparing* to open the law firm. Preparation, yes. There will always be people who quit a job and just go and open a business on a whim. And from those people, some will be successful. However, the most successful and

sustainably profitable businesses only open their doors after months, sometimes years of preparation.

To: Laura Ramos James
From: Anonymous Reputable Defense Attorney
cc: Paralegal Rosie

Subject: Re: Smith Case

Laura, Thanks for checking up on this matter. Let's circle back on Monday as my paralegal Rosie's out of the office today and nothing happens when she's out. She runs this place.

-Signed, Anonymous Reputable Defense Attorney

I remember getting this email reply a few years ago when I still worked for someone else. My first impression (and

one that lasted a few years) was: "Wow! Way to give cred-
it where credit is due!" Here was this senior, reputable
defense attorney, recognizing his paralegal's value to his
law practice and the fact that things only got done when
she was at the office. I smiled when I read his email and
admired him for it.

A few months before I left that same job, it dawned on me
that if I ever opened up my law firm (something that did
not seem to be in my immediate future, but was certainly a
desire), I likely could not afford staff. I'd been a lawyer for
a few years, yet I could not personally file a lawsuit. I didn't
know how to do that. I could *write* a lawsuit (a dang good
one, too). And then I could hand it over to someone and
hope it would magically be filed in court and the defendant
served with process. A paralegal running my imaginary
startup law practice was a luxury I probably could never
afford. So, I started learning the paralegal's job, and to
clarify, that is something you are not taught in law school
or in the actual practice of law afterwards, even if you are a
junior lawyer. It started with filing lawsuits. If my former
paralegals are reading this, everything's making sense to
them now. I had them teach me how to do their job. From
there, I moved on to the person in accounting and then our
legal assistants. At that firm, in addition to being the trial,

litigation, and managing attorney, I was HR, marketing, and the after-hours intake staff, so I'd learned on the job how to do those things. After a few weeks, I had learned how to do almost every single job position a small law firm had. At my law firm, I did those same jobs for a good while. Wearing those hats myself has proven invaluable to my law firm's initial development and long-term growth. Being able to do those three to four jobs saved me the money I didn't have when the law firm came to fruition, and now that we have employed people in those roles for a few years, I have a unique perspective. Their struggles, needs, challenges, and incentives are now second-nature to me.

Just like an electric drill or power tool is more certain to quickly impact a large rock formation than a drip of water, substantial resources can do the same for a business to some degree. However, consistency and discipline can not only ignite a small business into a great start and propel it forward for years to come, but also maintain it through tough times.

Any one person may be willing to do a number of things to achieve financial success. Yet, the sacrifices that are inherent to a long-term business can only be triumphantly suffered by someone who has a passion for the endeavor.

Find your calling and do it for a living; you'll find happiness.

If we can abandon our ego and the external/internal pressures that claim we're "too good" to learn or to do certain things, we'll be more willing to undertake the preparation that's needed to embark on the journey of, not just starting a business, which anyone can do, but starting a *sustainably profitable* business.

Key Takeaways:

Don't underestimate the power of discipline and consistency. Daily habits power monumental pursuits. Take time to find your calling—whether it's a few months or a lifetime—it'll be worth it. Doing our calling for a living is why we're all here. Prepare—nobody knows it all, not even the most gifted individuals.

Laura Ramos James

Laura Ramos James is the founder and owner of Ramos James Law, PLLC, an award-winning personal injury law firm headquartered in Austin, Texas. Laura's law firm handles serious injury and death cases, recovering millions of dollars for their clients each year.

Laura has been named *Up-and-Coming 100: Texas Rising Stars: 2023 & 2024 and Up-and-Coming 50: Women Texas Rising Stars: 2023 & 2024* by Super Lawyers™ and been recognized as "Top Personal Injury Attorney", "Woman Leader of the Year", and "Changemaker" by different organizations.

As a survivor of a catastrophic injury, Laura can uniquely relate to her clients and help them navigate their injury cases. For Laura, the most significant and transforming influence in her life has been becoming the mother of two little girls with her husband Jon.

Laura is a best-selling author, frequent speaker, and guest at lawyer and non-profit organizations and podcasts.

https://www.ramosjames.com/

https://www.instagram.com/law_law_land_tx/?hl=en

https://www.facebook.com/severeinjurylawyer/

https://www.linkedin.com/in/laura-ramos-james-b1807012a

8
Living in Alignment

Sarah Soucie Eyberg

"The expectation is that you will respond to text messages from partners within thirty seconds."

I was stunned, sitting in my three-month review at the first "real" lawyer job I had ever had. The partners had taken me out to lunch and were giving me rapid-fire feedback.

"Oh-okay," I stuttered. *Did he say thirty seconds?* There was an expectation of near-always availability at this job. One of the partners would receive emails with internet "leads" twenty-four seven. As soon as he received an email lead, he would forward it to an associate attorney. He

would also follow up with a text message, which we were required to acknowledge as soon as we saw it. We were expected to drop whatever we were doing and call that lead and screen them to see if they would make a good client. It feels like a shady practice—many people I called would be confused as they thought they were applying for benefits on whichever website recorded them as a lead. Unfortunately, it is not an uncommon practice in some areas of the law.

I sat there picking at my salad.

"I know you are scheduled to handle your first hearing next month," said Partner One.

"But we have serious concerns about your reliability," finished Partner Two.

See, this lead calling wasn't just an expectation during regular work hours. Or even the "expected" extended work hours for associates at the firm—7:00 a.m. to 6:00 p.m., with lunch eaten at your desk whenever possible. We were also on a rotating schedule of on-call nights and weekends. We were expected to be available for and call leads from 6:00 p.m. to 9:00 p.m. on weeknights, and from 8:00 a.m. to 10:00 p.m. on weekends.

One Saturday on-call shift, I overslept. This was the infraction that deemed me "too unreliable" to handle the hearing. The hearing that I had already reviewed, prepped the file for, and prepped the client and written the brief for. I was devastated. I always strive to do a good job in everything I attempt. I couldn't even mount much of a counterargument at the time. I *had* been late for that (completely ridiculous) on-call shift.

About a week before the hearing, I approached the partner who was replacing me. I laid out a persuasive case for why he should allow me to attend the hearing. It was a far drive, and I already knew the file and had spoken to the client. I was prepared and then he would be able to use his time more profitably. The answer was a resounding "no."

I quietly started looking for other work. However, I was looking during one of the worst climates for legal employment in decades. I graduated from law school in the spring of 2011. The following year, as I desperately searched for other employment, a report was released by the American Bar Association, revealing employment outcome data for the class of 2011. At the report's release, only 55.2% of 2011 grads had full-time, long-term *legal* jobs.[1] Another 26.2% of graduates were "underemployed," defined as "'Unemployed – Seeking,' pursuing an additional ad-

vanced degree, in a non-professional job, or employed in a short-term or part-time job."[2] To consider leaving that position without another lined up felt impossible, and ill-advised to say the least.

Things did not get better at the firm. My stomach ached on a daily basis. Every time my phone buzzed, I jumped. Every time the partners had a closed-door meeting, I was in trouble. My cortisol levels were through the roof, and there was very little time to recover in off-hours as I had multiple on-call shifts each week.

I was not the only one suffering; the partners continued to hire new associates. None of us knew what to do or how to demand better conditions. When the *attorneys* can't advocate for themselves, you are in a special kind of hell.

After a serious conversation with my spouse—who enthusiastically supported an end to the madness, I decided to leave the firm. A guy in my hiring class had already left shortly after his three-month review. He gave the customary two-week notice. The partners and other senior associates proceeded to *pretend as if he didn't exist.* He spent those weeks being passive-aggressively ignored. No exit interview. No communications about how to transfer

work. No instructions on how to turn in equipment. I couldn't believe they were so petty.

I wasn't going to endure the same. That Friday, I got to work well in advance of our expected 7:00 a.m. arrival. I cleaned my personal effects from my cubicle, left behind my firm-issued cell phone and security fob, and left a short, "effective-immediately" resignation letter on each partner's chair.

I walked out of that building with giddy laughter bubbling in my throat and my cheeks flushed with excitement. I didn't have a job lined up, but the weight lifted from my shoulders was incalculable. I started sleeping better, eating better, and finding more joy in life. I was more in balance, able to take care of my health and wellbeing and spend time with family and friends.

I found another position not long after. The job paid the same as my law firm job, but with a 37.5-hour work week, PTO, health insurance, retirement contributions, and disability, it felt like more than doubling my salary. My prior firm offered none of these essential benefits and very little autonomy—despite the fact that we were all educated professionals. While the American Bar Association would have likely categorized me as "underemployed," as the role

was non-practicing in recruitment and retention for the state bar association, I was much happier.

I had wonderful colleagues and I was still "law adjacent." I got to use and expand my legal network and tap into some soft skills I hadn't exercised in a while.

I missed client interactions and the intellectual challenges of practicing law, however, so I began to incorporate some limited client service on the side. Within a month or two, I was occasionally taking a day or half-day from my full-time job to attend a Social Security Disability hearing on behalf of another law firm for a fixed fee. The contract hearings were a nice supplement to my income and allowed me to keep up my litigation skills.

A short time into my tenure at the bar, my husband and I decided that with two solid incomes and health benefits, we might start trying for a family. Fortunately, it didn't take long for us to get pregnant.

Having only ever seen ultrasounds in the movies and television, I wasn't sure I understood what I was seeing. When the ultrasound technician paused the scan, I could see two little heads leaned up against one another, and two tiny little spines curving down. I blinked. And I blinked again.

Then it clicked. "Ho-ly shit," I said to my husband. We were having twins! Sharing the news with family was especially fun. We sent the picture of those two little ones leaning into each other to our parents and siblings with no context to see if they would see what we saw. "Wait, is that TWO babies?" was the most entertaining response we received.

While my pregnancy wasn't exactly uneventful, we all made it through, and soon we had two little babies at home. I was so grateful to be able to have three months maternity leave with Roland and Mina, even if only half of it was paid.

Our child care upon my return to work was a combination of my mother and a part-time nanny. Despite knowing the kiddos were in good hands, it tore at my heart to leave my vulnerable babies for hours at a time. It didn't help that I felt like a literal cow hooked up to the breast pump multiple times per day. I was really committed to breastfeeding, so I kept after it. Eventually, I cried leaving the house for work and cried on the commute home. I felt like I was doing a terrible job as a mother at home and a terrible job as a professional at work.

My mother stayed home with us when I was young. My father was a successful attorney with his own practice, and we could afford to live on one income. I was ambitious, though, even as a kid. I told myself often that when I grew up and had a family of my own, I was going to work full-time. This was not a reflection of my mother, I was determined to achieve! I didn't see the value in mothering. I was raised in a generation of "Gifted and Talented" kids, and no one was giving out prizes for Best Mom.

The twins were about ten months old when our affordable childcare arrangement fell through. My family helped us cover while we looked at other options. Living in Minneapolis, we fortunately had daycare options in our geographical area. But childcare openings can be rare, especially for infants, *especially for two infants simultaneously.* Even if we could find two infant openings, the weekly rates for infants approached two-hundred dollars per infant per week. Before even taking into account the extra expenses and time we would be taking to get two infants to daycare day after day, my take-home pay from my full-time job would barely cover it.

My husband and I were distressed. Life with two infants, plus their big sister Esme, my stepdaughter, was already incredibly demanding and draining. I just could not fath-

om working full-time for someone else to take care of my kids. We never really entertained the idea of my husband quitting his job to stay home. Not only was I still breast-feeding, but he made more than I did working as a lawyer at a downtown law firm.

We didn't feel like we had much choice, but I still agonized over the decision. I had spent most of my life working to get to this point. I had spent so many hours studying and so many thousands of dollars on education. Part of me felt like I was throwing all of that effort away, not to mention my identity, which up until that point had been centered on achievement and external validation educationally and professionally. It felt like a betrayal.

When I officially resigned to the executive director of the bar, with tears streaming down my face, his response shocked me: "You are doing exactly the right thing for your family." He went on to share that his family was fortunate enough to have his wife step back from her career to take care of their family. He also said, "Your kids are only going to need you this much for so long." That deeply resonated with me and a huge weight was lifted.

Choosing my family over my career was the right decision for me at that point in time, yet I still struggled with my

new identity. I wasn't a "working mom," even though I continued to handle contract hearings on the side. And I wasn't really a "stay-at-home mom" either because I did bring income into the home.

I continued to do the contract work through another pregnancy and the birth of my youngest child, Walter. I actually bid on a hearing just a few weeks after he was born because it was local and I would only be gone a couple hours. I generally was able to balance the demands of motherhood well while still bringing home some income to financially benefit my family. I started to get more involved in the bar association in a volunteer capacity, joining the boards of several sections, and eventually the executive council. I was able to attend Early Child and Family Education (ECFE) classes with Walter as well while Esme, Mina, and Roland were in school.

Eventually, I was attending fifteen to twenty hearings and was driving several hundred miles per month. The money was nice, but there were significant drawbacks. Most firms I was covering hearings for had thousands of clients. By the time the client got to the hearing date, they had often been shuffled from case manager to case manager, sometimes talking to a different person every time they called for a

status on their claim when they spoke to anyone at all. They didn't feel valued. I hated being a part of that.

I was exceptionally skilled at creating trust with the client in a short timeframe. I often would have one pre-hearing phone call with the client, and about forty-five minutes the day of the hearing to engender enough trust in my competence, ability, and compassion to facilitate a conversation around sensitive personal information, and figure out the best way to frame my questions to get the answers the client needed to give to prove their claim in front of the judge.

Knowing that I was able to provide value and compassion to these clients and that they were finally able to feel like their representative cared for them and understood them helped make the work tolerable.

Besides overlooking client care, these firms often overlooked proper case development. Case files were missing significant medical records and wage information. Many times I received a case brief that failed to take into account important age categories that would direct a favorable outcome or that was missing important medical impairments or past relevant work history.

Because I was the hearing attorney, I was essentially the "face" of the firm for both the clients and the judges I appeared before. I absolutely *hated* appearing at a hearing with an underdeveloped case file and an unprepared client. Many judges got to know me over the years and understood that the firm work product was not my work product, but I still hated feeling incompetent or underprepared.

One day I realized I had enough of the contract work, but I didn't think I had the infrastructure, knowledge base or entrepreneurial spirit to open my own law firm. I started applying for other roles and even interviewed a few times, but nothing ever felt right.

I was still doing contract hearings when the Covid-19 pandemic hit. Overnight, hundreds of Social Security Disability field offices and hearing centers closed their doors to the public. The next day I was supposed to appear for two hearings at our local office. I was nervous the hearings would still proceed despite the closure, so I showed up the next morning anyway, to be greeted by locked doors. I contacted the clients immediately after receiving the alert that the offices would be closed. I also attempted to reach out to the hearing office to ascertain how the hearings

would move forward and to the law firm that owned the file.

I had done everything within my power to ensure the hearings I was scheduled to attend could go forward. I had several scheduled for that first week of the shutdown, but only a few were actually held, between hearing office inefficiency and confusion with firms and clients.

One of the benefits of contract work is guaranteed income. Even if a hearing was canceled within seven days of the date, the firms would still pay me a partial fee. And if it was canceled within twenty-four hours, or the claimant didn't show, I was still entitled to the full fee because I had fulfilled all of my contractual obligations by showing up prepared to go forward with the hearing.

In the first week of the shutdown, I received a notice from the entity that brokered the firm-attorney relationships that firms would no longer be paying full fees for hearings that did not go forward due to the circumstances at the hearing offices. The notice also said the new policy would apply retroactively to the beginning of the shutdown.

I. Was. Livid.

I had been working with this company for more than eight years at that point. I always faithfully fulfilled my duties per the contract. I could not believe they were imposing such an unjust policy in such an unjust way. I thought about going after them for the fees, and I felt confident I would prevail. But ultimately, at only a few thousand dollars, it wasn't worth my time.

I was venting to my husband about the issue when I heard myself say, "I am just going to start my own firm. I am never going to be dependent on someone else for my income again!" I surprised myself with those words. My husband had told me for years I should start my own firm. I always had excuses not to do it. I traveled too much, the kids were too young, and I didn't have enough time. The real truth was I was scared to fail.

But now I didn't have any of the old excuses to fall back on. During the shutdown, there was no travel, and I stopped bidding for hearings. There weren't any extracurricular activities to run my children to and from. The fear was still there (*is* still there), but I didn't let it hold me back. I got to work.

While law school does a good job of teaching you how to think, write, and speak like a lawyer, it does not teach

you how to start and run a successful law firm. I did not have much business background, so I sought out business coaching to make sure I was making the right moves for my firm and joined the Lawyerist.

One of the foundational exercises the Lawyerist coaches ask participants to complete is drafting a mission statement, vision statement, and core values for your law firm. I was so resistant to drafting these, mostly because I was unsure of where to start. I had never examined my own core values before. I knew the values I was raised with. "After your health and your family, what is the most important thing," my father would regularly ask us.

"A good education!" we would chime in. But this is the first time I was really *testing* my values, and broadcasting them to others to examine and critically evaluate.

I realized I had already been living my values without even knowing it. The law firm was such a bad fit for me because there was no work-life balance for employees and I was not treated with respect as a professional. I agonized about leaving full-time work because I value achievement and success, but not as much as I value my family. There is nothing I wouldn't give up for my family, and I married a partner who is the same way—one of the many strengths

of our relationship. I was furious with the actions of the contract hearings company because I value loyalty and integrity so much, both in myself and in others.

The pandemic acted as a crucible for my core values. Not only did I build my firm from the ground up using those core values, but I also used those core values to scrutinize all other aspects of my life, professionally and personally. I looked at where I was spending my energy and resources. I evaluated whether those organizations and endeavors made good on promises of diversity and equity and whether they advocated for the status quo or led the charge for progress.

Another foundational exercise for starting my law firm was drafting a mission statement. A mission statement should describe what your firm does, how you do it, and for whom. Look on any number of law firm websites and you are likely to see some version of the same terrible mission statement: "Stuckup Lawyer & Associates mission is to be the premiere [insert practice area] law firm in the [insert geographic region] area!" Not only is it lacking in inspiration, but it also says nothing about your firm or firm culture other than one of your practice areas and where you are located. Potential clients can easily discover that elsewhere.

To draft my mission statement, I asked myself a very important question: *Why?* Why did I want to start my own firm? Why does my firm need to exist when there are other firms out there doing the same work? Why should clients hire me over the competition? Why? Why? Why?

Only through a thorough examination of my motives was I able to clearly articulate what I wanted my firm to do, for whom, and how. I refer back to the mission statement once per quarter to make sure I am running my firm in alignment with that mission or determine if I need to redraft the mission to fit what my firm is doing.

A powerful vision statement is also essential. This is often and easily confused for a mission statement, and some businesses use them interchangeably, but they are distinct. While a mission statement should tell the reader what you do and how, the vision statement should explain why what you're doing matters and where you are going. Your vision statement should be aspirational and act as a guidepost for where you want to be in the future.

When I sat down to draft my vision statement, I thought back on all the hundreds of hearings I had performed for other law firms. One common experience for all of those clients was confusion about the disability process and

frustration with the lack of clear communication from their representatives. My vision statement centered on creating a different experience for clients through this already difficult experience. I wanted my clients to feel empowered and informed while working with our firm.

Lastly, I went through the process of defining my firm's core values. As someone who cares passionately about a lot of things, this was a challenge. There are worksheets out in the ether with a list of values to choose from, and that can be a good place to start, but it was not exhaustive. A business's core values should reflect what the firm culture is and how it's known to others. It should also inform what the firm priorities are and how it will meet challenges.

My core values should have meaning beyond simply sounding good on paper. My core values would be intertwined within my workflows and systems, a part of my marketing strategy and informing how I deliver client services. I needed to be able to define what each core value means to my business, and how I implement it in my business operations.

One of my business core values is "straight-dealing," meaning we are transparent with our clients. In order to live that core value through my business, I am direct with

clients about the strengths and weaknesses of their cases. I clearly set their expectations for our services from the initial consultation to the conclusion of the matter. We regularly provide case status updates and employ automations to streamline communications.

A benefit to going through these exercises for my business is that they provided me with the tools to evaluate my core values for my personal life. Once I had clarity on those values, I realized that every major event in my professional life thus far, and especially my response to those events, was informed by my core values.

That icky feeling in the pit of my stomach every time I went into the office during that first law job was my gut telling me I was out of alignment with my core values. If I had better clarity on how important work-life balance was to me at the time I interviewed for that job, I could have asked about the firm's expectation for hours worked and "seat time." It would have made it easier to walk away from a job where management was focused more on exploiting associate labor than developing professionals to practice.

If I had better clarity on just how important children and family were to me—much more so than career aspirations—I would have felt more secure in my decision to step

back from my career to raise my kids when they were very small.

If I had known how important a reputation for competency and excellence was to me earlier on, I would have understood why I was suffering during contract work and I may have had the confidence in myself to start my business sooner.

In the years since I began my business and defined many of these values, and others including quality work, access to justice, and professional excellence, I have achieved more job satisfaction and fulfillment than I thought possible. Knowing my core values has helped me to know which opportunities to undertake and which to decline. It has even helped me reevaluate relationships with individuals and organizations and focus my energies where they matter most. Defining my core values has allowed me to become progressively more authentic in every area of my life. I can be authentic because I know what is important to me and I am confident in my ability to make the right choices. I am free to be me.

Key Takeaways:

Living your core values is the foremost way to prevent burnout and achieve success professionally and personal-

ly. Others will sense your attunement and want that for themselves. The only person who can define those core values is you, so don't wait any longer.

1. Lynch, Parick J., et al. "Class Of 2011 Legal Employment And Underemployment Numbers Are In And Far Worse Than Expected," *Law School Transparency,* 15 Jun 2012.

2. Id.

Sarah Soucie Eyberg

S arah Soucie Eyberg is the principal attorney of Soucie Eyberg Law, LLC, practicing exclusively in the area of Social Security Disability law. Her dedication to professional excellence, development, and service knows practically no bounds (just ask her husband). She is a member of several local and statewide legal organizations, and serves in leadership roles in nearly every organization.

Sarah is a runner, knitter, deer hunter, mother, wife, and attorney living just outside the Twin Cities with her husband (Jason), four children (Esme, Mina, Roland, and Walter), cat, and chickens. When she is not working, she can be found at home with her family, trying new recipes

or passing on her love of reading to her kids. She also passes all of her nerdy fandoms on to her kids, including Doctor Who, the Marvel universe, all things Halloween, and more.

https://www.facebook.com/mndisabilitylaw/

https://www.linkedin.com/in/sarah-soucie-eyberg-1014a642/

https://www.instagram.com/mndisabilitylawyer/

9
Full Circle Magic

Sandy Stewart

Mycelium networks are the tiny threaded "roots" of fungi that form the communication network underground between trees. They transfer water, nitrogen, carbon, and other minerals so the trees get what they need. It is a shared economy that ensures growth and nourishment across the entire network. Without this interconnected "brain," trees would have to fend for themselves, and their growth and nourishment would be limited to what they could create on their own. This communication system is astonishing, elegant even.

As an expert in sustainability, I am enamored by the natural world, with a vested interest in preserving it. But what

often fascinates me is the way seemingly unrelated systems mirror one another. In the same way this network and interdependence among trees generously nourishes all the branches, I witness a similar correlation among other things too: people, economies, and especially businesses.

It's this last one, a lesson about business and the importance of creating strategic alliances and systems of support that I've grown to value more than ever, because a few years ago I lost everything and had to completely start over.

Beginning in July 2006, I built a business coaching and consulting company with my now ex-husband. We started with just a few key relationships. We nurtured those relationships and developed strong referral networks, which expanded to a rich ecosystem of strategic partners all working toward the same goal...providing everything our clients needed and doing it with the clients in mind. We all flourished, and our clients thrived. Without those strategic alliances, we would never have added multiple locations or even built our business beyond ourselves.

We went through some tough times in our marriage that sucked up all our attention, and our business took the hit. We were both so burned out, and it felt impossible to keep

the business going. When our relationship ended, I got the business, or rather what was left of it.

I spent the next three and a half years trying to make it my own, trying to change it enough to fit me, which only sort of worked. Somehow through sheer determination, I experienced increments of growth and even began growing a new small team, but I was still so burned out, and it took everything in me to experience any kind of growth at all.

Nine months prior to the pandemic, my business was suffering a continued slow decline, and I couldn't figure out what wasn't working anymore. I just stopped being able to get clients. My nerves had been frazzled and overworked for so many years, and I barely had any energy left to muster. It felt like I was burned out from my burnout.

What I needed was a wake-up call, which came just before the pandemic. I had been operating a business that no longer served me. It no longer fit my passion or my values, and on top of that, I was spiritually worn out from years of chronic complex stress followed by a painful divorce riddled with betrayal. I was just cycling on that same track but now going nowhere, my wheels spinning without gaining any ground.

I was operating in the shadow of my former self. I had lost all zeal for my work. My fear of success and addiction to achievement had a dark underbelly of extreme self-reliance that kept me from asking for the help I needed.

Stopping something that had defined me for the past eighteen years was a shock to the system. I couldn't talk about it, because I was embarrassed about what felt like utter failure. I felt like my business was a failure, my marriage was a failure, and I was a failure. And it felt wrong, but secretly I was grateful when the lockdown happened, because it meant no one would notice that I was going to put my business and life on oxygen, so I could coast for a while. This was how I was going to figure out what was next.

After lockdown, I lost 85% of my revenue in just two weeks, because my well-diversified client base all had to pare down, furlough employees, and shrink in massive ways that included letting me go too. Apparently, I was meant to speed up this whole idea of moving on and repositioning myself. Okay, got it.

Point taken.

In this moment, it felt like my "roots" had been cut, and I had to start all over from scratch. And THEN, I lost my mom to Covid, and lost my health to a weakened pancreas,

along with five other new ongoing digestive ailments. Oh yeah, and I had to find a place to live. Staying with friends and family in the middle of a pandemic gave me a sense of compassion for myself and a sense of hope in the midst of feeling torn apart, lost, and exhausted.

So here I was, feeling like a failure, feeling like I was in grade school all over again. I questioned myself more often than I made decisions. I struggled to find clarity about who I was and what business I wanted to be known for. I wasn't even sure what business I wanted to be in anymore.

It was a journey of letting go of old ideas about myself, finding humility in what I'm capable of, and surrendering to different possibilities than I could have ever imagined for myself.

I understood that to be successful on my own terms I needed to grow new roots and rebuild my network. But I also knew that I needed to clarify for myself exactly what I wanted to grow.

Having been so self-reliant for so many years, my new journey became one of asking for help, asking for feedback. My new mantra was "I can't solve the shit in my head with the shit in my head." So I started talking to others, reading, listening to podcasts, everything I could. Soon,

I found an online group course about purpose. It challenged me in ways that made me feel extremely uncomfortable. I almost quit several times, but I stuck with it, and more than halfway through, it hit me. I had this burning bush experience. An epiphany. It became crystal clear: My purpose in life has nothing to do with the work I do for income. Let me say that again for those in the back...my life's purpose has NOTHING to do with the work I DO. It is, however, being the spark that ignites momentum for someone's next big wave, and my job in this life is to live my life in such a way that my superpower is lit up and engaged. (Mind blown!)

This realization that I could literally choose to do anything and still be in alignment with my purpose freed me up and took some of the pressure off.

If I was going to do anything that would fill my heart and make me happy, it needed to be something that was adding value to this world, not taking, using, or wasting this world. Do you remember that Keep America Beautiful commercial from the early seventies where they zoomed in to a closeup of the Indigenous American who had a tear in his eye? I was only little, but that visual tattooed so much love and respect for this planet on my heart, it has never left me. So, when I hit a crossroads of deciding which way

to turn next, it seemed only right that I do something to help make this world a better place.

I didn't want to just help ANY business grow. I wanted to help businesses that care about the planet, care about their local communities, care about society.

This led me to go back to school for sustainable leadership through the University of Cambridge, where I began to redefine my work. There, I found myself surrounded by people from so many other countries, most of them forming or leading departments of sustainability for large companies, international banks, major UK grocery chains and innovative companies inventing new products, solutions and systems. It was thrilling, to say the least. It gave me a vision of what a giant wave of small businesses could do who are all on the same pathway toward a sustainable and just future.

It has felt like a long slow journey for me to think of myself as not just a business growth and value expert, but a sustainable business expert who also happens to geek out on the science and the metrics of carbon footprinting. I love helping businesses figure out or get back to their "why," their raison d'être. Even if people don't agree socially, politically or any other-ly, I believe at our core, we all have

something we care about, something we are passionate about. And these things could be a direct outcome of a person's business model or the work they do or it could be what they give to in their spare time. Either my business is feeding my "why" or I'm aiming to make enough money to support my "why" in my personal time. Either way, I'm in alignment with what I care about, and that is winning.

While I do care about our planet, what I love about sustainability is it isn't just about carbon footprinting and going green. It's also about how a company takes care of its employees, how they connect and support their community or ways that they give back. This social impact is a huge part of why this work makes my heart sing. It feels so fulfilling, and it's another avenue to work with my channel partners and clients. Previously, I was training business strategy, building sales teams, creating operational efficiencies, and growing company value. Shifting toward sustainability feels much more feminine, much more caring, giving, and loving. My heart has become happy, very happy.

So how hard is it to find small businesses that are looking to become thriving sustainable brands? Well, they're not knocking down my door. It takes a lot of educating on my part to show them that by threading sustainability into

their business model and operations they'll reduce cost, lower risk and increase customer and employee loyalty. Once they see that they don't have to spend a lot of time or money AND they'll shore up these big benefits, it's a no-brainer. But it takes a lot of talking, telling, and sharing, so referrals and introductions are necessary. The need is there, but businesses need to understand what becoming more sustainable can do for them.

THIS is where the relationship building comes in. Networking is vital to the growth of my business.

Susan Hagar said, "Get a seat at the table or build your own table." She founded the National Association of Women Business Owners (NAWBO) nearly fifty years ago. Two years ago, I co-founded a NAWBO chapter in Austin, which has become a gathering space for like-minded professional women who understand the importance of community. I believe I am a reflection of the company I keep, so I decided to build my network around me.

But really, you don't have to launch a community organization like I did to connect with potential channel partners. When I'm at any event or networking function, I'm not looking for clients. I'm looking for potential referral partners. Recently, I connected with a company making

compostable packaging made from plant-based materials. They have clients who need help growing their businesses and calculating their carbon reduction by using sustainable packaging. If I help their clients with this, it helps build client loyalty and ensures growth for the packaging company since those clients will see their own growth tied to such smart packaging.

I've also identified that CPAs make great partners for me, because they often act as a resource for their clients and need experts in their corner to serve their clients well. I look for the ones who serve the same market of small businesses that I do. They know their clients' businesses deeply and are in a prime position to make introductions to those that they already know and trust to help their clients in ways they don't. It creates client loyalty to them, builds trust in them as a strategic advisor, and they get brownie points for bringing qualified experts to fit their clients' needs. Win-win!

So now I'm partnering with other professional services such as CPAs, business attorneys, commercial bankers, financial advisors and HR consultants, finding the ones that serve a similar market and that share the same values. We hold events together, webinars and master classes, and we work together to help our clients succeed in every way.

Recently, I presented on a webinar hosted by a financial advisor who focuses on impact investing, and I'll be sitting on a panel for her at the end of this year because of it. She saw me speak at a networking luncheon and said she just had to have me come speak to her clients and share the same information with them. Talk about validation!

It takes time to meet with twenty to thirty potential strategic alliances to find the few that truly fit, but once we find each other, the opportunities we can create together for now and long into the future, far outweigh any time now finding the right ones.

Channel partnering is the small business economy equivalent to mycelium and how it connects all the trees. It's all about playing the long game with strategic alliances. In previous years, when I was focused on training businesses on value growth, other consultants and coaches treated me like competition. It's so different in the sustainability space. Everyone has such an abundance mentality, and we all want to see each other thrive and do well. Since we all have the same ultimate goal, we all know we're on the same team. With over thirty million small businesses in the US, we will hardly bump into each other. There is plenty of need to go around. The fellowship is so refreshing.

Here's what I really love about building strategic alliances, and why I'm pursuing them myself. It's one relationship to manage potentially many new ideal clients. It can create a steady stream of opportunities and clients for years to come. So the relationships I'm creating today will be paying off for both of us year after year after year. And honestly, what a treat it is to build my tribe of like-minded businesses that are working together toward something greater than ourselves. It's such a giving and thoughtful way of doing business—constantly considering what my clients need (or will need) and pre-vetting those suppliers for them.

Receiving one of my first referrals after I made this shift was so incredibly validating. A woman I have grown to love through my new networking efforts referred one of her top clients to me. It was the validation I needed at that time. She was instrumental in working with me to launch the women's business owner association, and through working with her, I developed so much respect for her business acumen and her professionalism, it meant everything that she thought so highly of me to send me her valued client. It was all the more magical because that woman's name is Faith. This single act helped me to have faith in myself.

What a gift it is to know that someone thinks so highly of me and what I'm capable of that they referred a precious relationship of their own. And when I've done a good job for them, and they thank the initial referrer for introducing us...it's full circle magic! And we are all nourished by the exchange.

And frankly, I just don't want to do this alone. I get so much inspiration and encouragement from others, it's so needed in a space that can feel like an uphill climb every day. Having an ecosystem of businesses that are all working together to better our clients' businesses and working toward greater causes, it's a lot more fun than going it on my own.

I'm seeing business and industries in a whole new way, shifting to a new way of doing things. Consider oil families or businesses who think of themselves as being in the business of oil. What if instead they actually realized they're in the business of energy. It would be such a clear opportunity to add alternative energy into their asset mix and take advantage of this fast-growing market shift. It has already happened in other major industry shifts in our history. Consider train travel. There was a time when trains were the only way to travel across the country, then airplane travel came online. If those train companies thought of

themselves as being in the travel business, rather than the train business, they'd have transitioned to add airplanes to their mix and flourished as the world shifted. Those railroad companies would own the airline industry today. For the oil businesses to add alternative energy to their assets, they would have the opportunity to take the lead as the world transitions. It would shore up future reserves for their own generational transfers.

Today, businesses, consumers, and customers want to know what a company is doing, and what a brand cares about. Over the years, I have worked with dozens of CPA firms, and regularly I saw them giving back to their communities, either with volunteer days or fundraising for a cause. Yet, hardly any of them spoke about it publicly, so most of their clients didn't know.

As I've understood more and more about what a sustainable business is, what it does, and what that can do FOR the business and FOR society and our planet, I have been getting really clear about who I need to partner with to create my mycelium business connections. It's now clear to me that all the training and experience I've racked up all these years has led me directly to now. I don't have to give up on the tacit knowledge I've developed over these years. At first, I thought it had to be a full-on shift to

sustainability, but I realize that I'm still very much an expert on strategic planning, scaling companies for growth, operational efficiencies, and growing company value. Now all that is wrapped with the added context of sustainability. This is where the world is shifting anyway, so why not lead the charge for small businesses moving into a new, different, softer, more feminine, loving, caring way of doing business? It's more communal, less competitive, more interdependent.

So here I am now, speaking about changing the way we do business, injecting this feminine energy of love and care for our communities and our planet into our business models, helping entrepreneurial upstarts to build thriving sustainable brands, and feeling spiritually fed from work that I love.

This may feel a bit "out there," but it really is how I see businesses. I have come to see them as living, breathing entities, organic matter, just like you and me, just like trees. What we feed our businesses, we get out of them in return. If we stop feeding our businesses with fresh ideas, better processes, inspiring strategies, then our business will fail to thrive. Taking care of a business's health is key to long term survival, just like taking care of our own health is key to our longevity. I'm sure you can imagine a business that feels

vibrant, healthy, warm and loving versus a business that feels cold, mechanical, stiff and transactional. Businesses have personalities just like people do. So, I think of strategic alliances as my business becoming BFFs with another business. Together we create a shared economy that helps us thrive individually in ways we could never do alone. It's an astonishing system, elegant even—and built upon a strategy that is as joyful as it is impactful.

Key Takeaways:

When running a company, our growth is multiplied when we align with others to help spur things along, so if real growth is what you're interested in, find your tribe and grow your businesses together. You don't have to do it alone, taking the time to connect with partners who align with your values and vision is THE key to success.

Sandy Stewart

Sandy Stewart is the creator and founder of Think Big, a sustainable business support and training program for small and mid-sized businesses. Her twenty-three-year career helping SMBs and SMEs grow value now has an added focus on sustainability and growing through strategic alliances. She believes that companies that care for their people, their customers, and their community have a duty to run a profitable, thriving business.

Today, she's a speaker, trainer, best-selling author, social impact strategist, carbon footprint specialist, value growth expert, small business advocate, and board member. Her current volunteer work includes Past President & VP/Treasurer for Tapestry Dance and founder and chapter chair for NAWBO Austin.

https://www.linkedin.com/in/sandy-stewart-9534a/

https://www.instagram.com/thinkbigprogram/

https://www.thinkbigimpact.com/

10
Quietly Reclaiming My Voice

Sarah Warner

"You know he wants you fired, right?" Archer stated with a hint of amusement.

My cheeks were flushed from angrily stomping up the stairs in a pair of stilettos. My entire body radiated heat and my neck was splotchy red, but thankfully concealed by one of my many floral scarves. Even though I stopped to grip the railing on the landing and steady myself before walking into Archer's office, my heart still pumped erratically. Outwardly, I appeared to be fine—hair in place,

makeup freshly applied, and my favorite navy dress expertly pressed.

Internally, I was seething as I quietly sank into the chair across from Archer and calmly but firmly replied, "That's not happening."

Archer didn't say a word. He gave me time to breathe. He waited for me to elaborate.

This wasn't my first time in Archer's office debating this issue. My boss, Cooper, had become unhinged after a department meeting. In the aftermath, I was called into his office, along with two team members, and verbally abused. The spitefulness with which Cooper accused us of "being unprofessional" because we had been "discussing challenges and concerns" with others stunned us all into silence. He warned that if we didn't do exactly what he had asked, "it would be [our] fault if we didn't reach the fundraising goals." Attempting to confront Cooper only led to more yelling and threats that he would be "setting up individual meetings with HR" if we didn't toe the line. So, we demurely acknowledged his request before slipping out of his office.

Exasperated, and knowing Archer would keep everything confidential, my venting continued, "You know I'm not

the only one who feels this way! Cooper's behavior is creating a toxic work environment. It's not about this specific incident. It's about a host of wildly inappropriate activities we've already discussed that are impacting the entire department, not to mention the larger organization. I'm beginning to worry about what he is promising donors and volunteers. Honestly, Cooper has to go, or I, along with others, are prepared to quit."

Archer appreciated the dilemma I faced because even he was considering leaving, albeit for different reasons. Throughout my career in nonprofit fundraising, I'd dealt with a handful of less-than-ideal bosses, coworkers, donors, and volunteers. Thankfully, those unpleasant situations were typically offset by the accomplishment I felt working with inspiring leaders, dedicated colleagues, generous philanthropists, and supportive volunteers. I prided myself on doing the right thing, working hard, and advancing on merit. Yet, I was at a loss for how to salvage my role within this particular institution because of Cooper.

Begrudgingly, I agreed with Archer that I should try to cooperate, mainly because I didn't wish to fight anymore, and attempted to turn my attention to stewarding donors and cultivating prospects.

In my quest to lessen the explosive interactions with Cooper, and frankly keep my job, I started down a rabbit hole of researching topics like dealing with difficult bosses, narcissistic leaders, and toxic work environments. In one particular article, I unexpectedly came across a widely used quote I had forgotten that reminded me of something far more important: "Confidence is quiet. Insecurities are loud." This concept ultimately reflected how I shifted my mindset in handling the situation with Cooper. I silently questioned whether his bombastic nature was covering up his insecurity or if he simply felt rules didn't apply to him. Alternatively, I wondered if he merely took pleasure in systematically gaslighting people.

My behavior changed in the days and weeks that followed. I did not speak up in meetings nor did I argue about assignments. I made an effort to be more docile and professional. I even bit my tongue when someone dismissed Cooper's behavior as "boys will be boys." My passion for the work diminished because I felt like I had lost my right to voice my convictions.

An inordinate amount of time was also spent with those equally frustrated with Cooper. There was a collective realization that while several of us were prepared to lose our jobs, this was not a battle that we were equipped to fight

alone. Unfortunately, a few planned to soldier on because they didn't have time to do their work and document the problems he had caused. We needed allies from my team, other departments, and leaders who operated at the same level or above my boss. After consulting with a handful of trusted partners, we confirmed that people outside the team were willing to speak up for themselves, or at least let us share their challenges in working with Cooper.

The breaking point finally came, not when something happened to me but instead to someone else within the organization. Cooper's behavior had been so egregious that we all agreed enough was enough and it was time to speak. A core group discreetly met with one of Cooper's superiors to express concerns while a couple of brave individuals approached this same leader to reiterate the seriousness of the issue. The more people talked and shared, the clearer it had become that Cooper's actions went far beyond rude or toxic; they warranted legal action.

This was how I eventually found myself seated in a tiny, musty room that I'm not even sure had windows to the outside and that I honestly didn't know how to find within the building until that day. Seated across from me was Evelyn, who had been brought in to investigate the situation.

Evelyn assured me she had already spoken with a select group of employees, so she had a fairly good sense of all that had happened and encouraged me to speak freely about my personal experiences. As we delved into specifics, Evelyn frantically filled page after page of her yellow legal-size pad with handwritten notes as I described difficulties with Cooper.

Remember when I mentioned changing my work behavior? During the time I kept my head down and my mouth shut, I had also documented interactions with Cooper, as well as the conversations I'd had with trusted colleagues. I was now in a position to share this with Evelyn.

I conveyed to Evelyn something unlikely to have come up in her previous conversations when I opened with, "People forget I have a degree in human and organizational development. I've studied psychology, interpersonal communication, collaborative work behavior, leadership, and management, not to mention having taken classes in analytic and critical thinking skills where you are asked to define as well as solve personal and organizational problems."

Evelyn seemed intrigued by this as I elaborated, "I always loved the idea of working with nonprofits where you get to work with donors, volunteers, and colleagues to support

a worthy cause or a meaningful project. However, I never imagined I would be sitting here explaining that I know what cognitive dissonance looks like or that I could do a capstone project on how to create a hostile work environment based solely on one person."

As Evelyn wrote, I added how Cooper instigated conflict by giving peers different information or instructions. Even if we had collectively agreed to do or not do something in a meeting, side conversations with Cooper led to arguments around "that's not what he told me" or "he said I could do this." If you asked for help resolving conflict, Cooper criticized you for not being cooperative. His whole demeanor encouraged competitiveness, not collaboration.

He didn't seek advice or listen when it was provided anyway, all in the name of trying to protect relationships with donors and prospects. Cooper could be so charming and engaging with superiors and donors while treating peers, and especially subordinates, with complete disdain, not to mention being obnoxious and demeaning. I lost track of the times I spoke or wrote to apologize with, "I know this isn't the way we do things, but Cooper demanded it" or "I'm so sorry that happened, I told Cooper we couldn't do this" or add, "Cooper won't take 'no' for an answer. Can you ask your boss to intervene?" I even had to help

figure out how to mitigate a promise Cooper made to one of my donors that never should have been offered in the first place.

Protocols and procedures also existed for how to handle donor gifts. Yet Cooper didn't seem to care on an occasion when a donor gave through a donor-advised fund, which meant legally "no goods or services [could be] provided in exchange for [the] donation." Not surprisingly, he wanted us to try to circumvent going back to the donor for a separate gift that would not be tax-deductible to cover the "fair market value" costs if they attended an event. In another meeting, misleading numbers were presented where totals included a few unconfirmed commitments. For context, I always distinguished between gifts of cash (money in hand), pledges (binding with written documentation), and verbal commitments (non-binding because paperwork has not been created or signed). Fundraising projections were also off by hundreds of thousands of dollars because Cooper (along with another colleague) had failed to factor in gifts coming in below proposed ask amounts or declined outright. Funding benchmarks were likely to be missed because of this lack of accountability. This was on top of all the ways Cooper had trampled over the objec-

tions regarding a variety of things all in the name of doing things his way.

I revealed to Evelyn, "This is mentally exhausting. I'm beginning to question my psychological safety at this point. I've dealt with challenging people in the past, including some fairly narcissistic personalities, but this is on a whole different level. I want to quit."

Evelyn finally set her pen down and studied me carefully before responding, "I'm not surprised at all by how you feel. What you have been describing is considered sociopathic behavior."

Seriously? Did I need to add questioning my physical safety to my list of worries?

Looking back, Evelyn was correct in her assessment. Cooper was manipulative, deceitful, impulsive, and had no regard for the rights or the feelings of others. Evelyn validated this.

The crippling anxiety that had caused so many sleepless nights of tossing and turning followed by equally grueling mornings of trying to pull myself together to go into the office began to fade. The tough interactions that had often left me privately crying and screaming with resentment

seemed worth it. Leadership had listened to us. I found peace again in my morning ritual of popping into the neighborhood coffee shop to grab a latte, and after work, I could once again relax with friends over a cocktail without constantly agonizing about the problems I'd been facing. An oppressive weight lifted making it not only easier to breathe and share my thoughts but also to find joy in little moments.

It was empowering to know that I, along with a handful of others, had spoken up to say what we were experiencing was unacceptable. The grievances reported to HR and later shared with the investigator led to Cooper's departure. However, it likely felt unexpected to those blissfully unaware of the scale of the drama that had taken place in hushed voices behind closed doors.

And yet, we were now a fractured group reeling from being misled by a divisive leader. Those first few meetings with the department and HR were fraught with anger and hurt because of how everything had been handled. I tended to keep my mouth shut and head down, although I wished I'd spoken up more. Differences of opinions and perspectives needed to be addressed but certain questions couldn't be fully answered because of the investigation.

The ones lucky enough not to be caught in the crossfire of Cooper's actions undoubtedly felt blindsided by it all.

Despite the tension, there was a sense of redemption as everyone banded together. I was reminded of the reasons I had taken the role in the first place. I respected the institution. I believed in the mission. I cared about the entire team. I wanted to make a difference. The collective success of the team was celebrated once we finally delivered on the project funding.

· · · · · ● · · · ·

Building relationships was (and still is) the hallmark of my career but in the darkest moments of dealing with Cooper, I felt defeated. Under duress, I lost sight of key characteristics that had made me an effective fundraiser: confidence, trust, and collaboration. I questioned my abilities. I doubted my boss (for good reason). I distanced myself from working with certain team members (because of mistrust and infighting). In speaking out, I finally found my voice again and built a handful of amazing work relationships that would later evolve into close friendships.

I've always been startled when someone's confidence is perceived as a threat when it is the other person's inse-

curity that creates this interesting dynamic. A quote by Maya Angelou states, "Words and actions may fade from memory, but the emotions and feelings associated with those experiences tend to stay with people for a long time." The mentors who shared invaluable lessons with me at the beginning of my career understood this concept. The leaders who inspired me the most over the years are ones whose words and actions reflected a sense of genuinely caring about the staff and the organization. While they set expectations at the highest levels, they did so in a nurturing manner. If I asked questions, they clarified the details. If I made mistakes, they helped make it right. If I wanted to explore an alternative approach, they helped encourage and guide my efforts. They embraced the idea that if you want your staff to accomplish their best work, then you must be there to not only support them but also bolster their confidence.

With this as a reference point, I knew Cooper's aggressive style wasn't going to work for me. However, rather than simply quit, I needed to be sure I wasn't the only one who felt this way.

Susan Cain's book *Quiet: The Power of Introverts in a World That Can't Stop Talking* has a passage that has stayed with me over the years: "Introverts need to trust

their gut and share their ideas as powerfully as they can...ideas can be shared quietly, they can be communicated in writing...they can be advanced by allies. The trick for introverts is to honor their own styles instead of allowing themselves to be swept up by prevailing norms."

I realized my confidence is quiet and having a voice doesn't always mean raising it. While I was not the leader of my department, I could use my voice to influence others for the greater good. I will always be grateful to the group, led by several strong-willed women, who, given their titles, were in a position to more forcefully articulate to leadership the growing discontent around my boss's behavior. This approach proved to myself (and others) that you didn't need to be loud to be heard or threatening to be effective.

Cain's book also pointed out, "I worry that there are people who are put in positions of authority because they're good talkers, but they don't have good ideas. It's easy to confuse schmoozing ability with talent. Someone seems like a good presenter, easy to get along with, and those traits are rewarded...but we put too much of a premium on presenting and not enough on substance and critical thinking." Given the drama Cooper created by insisting everyone do things his way or with complete disregard for established norms and policies, I couldn't agree more.

A younger version of me had placed almost blinding faith in mentors and managers to the point that I would do nearly anything to ensure a boss, donor, volunteer, and coworkers were pleased with me. In the wake of Cooper's betrayal of my trust, I learned to stand my ground when something didn't feel appropriate. I did not raise my voice. I measured my responses. I changed my tactics when needed. I started asking myself and others "What has been done in the past?" and followed up with "Can this be done differently? More effectively? More efficiently?" The answers informed the decision-making process. While I'd always appreciated the need for innovation, I wasn't willing to implement change for the sake of change for the whims of someone who wasn't interested in weighing the consequences.

Naturally, there are definitive inflection points when you realize change is essential. Honest and open conversations with colleagues couldn't take place without trust. As I worked to create unity amid Cooper's divisiveness, I found my voice by employing empathy and creating a safe space for transparent and authentic conversations to take place that would move us forward.

Harvard Business School professor Frances Frei delivered an informative TED Talk on "How to build (and rebuild)

trust," in which she expounded on a framework for building trust that has gained popularity in recent years. It entails authenticity, logic, and empathy. Frei pointed out, "If any one of these three wobbles, trust is threatened." I found comfort and hope in knowing that her "favorite trait is redemption...that there is a better version of us around every corner, and I have seen firsthand how organizations and communities and individuals change at breathtaking speed." And I was counting on the team to be in a better place once it emerged from Cooper's destructive grip.

While I had instinctively cultivated trust as a fundraiser over the years, I appreciated that it would take a deliberate effort to rebuild trust internally. To truly be empathetic, Frei instructed that one must "look at the people right in front of us" and "deeply immerse ourselves in their perspective." This is how I had approached many of my conversations with those who became allies, while later it helped me rebuild relationships with those I had alienated.

For me, the most illuminating aspect of Frei's lecture centered on logic. I fully appreciated that "often the logic is sound but the ability to communicate it is in jeopardy." I normally employed the "upside triangle" when speaking with prospective donors, which allowed me to take some-

one on "a magnificent journey with twists and turns, mystery and drama, until you ultimately get to the point." This is not always the safest approach. I reversed my communication style for the initial conversation with leadership and the tense department meetings that followed. Frei's advice was "start with your point in a crisp half sentence and then give your supporting evidence...if you get cut off before you're done...you still get credit." This gives the listener immediate access or context as to why you are there or what you are asking for rather than the potential pitfalls of questions being raised before you have a chance to fully explain.

The final piece in Frei's trust framework is authenticity. I loved how she essentially deadpanned "be you" paused before offering "great" and left you to wonder if she meant that as a statement or as a question mark. She clarified that you should "pay less attention to what you think people want to hear from you and far more attention to what your authentic awesome self needs to say."

It was almost effortless to be authentic when I pitched for investment as a fundraiser because I could speak passionately about why a project was important. A manager once described me as "one of the most intuitive fundraisers" she had ever met since I seemed to know what needed

to be said or done to move a gift conversation forward. However, after years of molding myself into other people's visions of what I should be, I had lost my sense of self. As the fiasco with Cooper unfolded, a deeper awareness of my motivations, beliefs, and values emerged. Thankfully, I walked away with a renewed sense of who I was and what I was capable of achieving.

Nevertheless, I understood that no matter how lofty my ambitions or goals might be, success was rarely a solo endeavor, which made building trusting relationships paramount.

· · · · · ● · ● · · ·

In the face of adversity, I didn't fall silent. Reclaiming my voice required confidence in my strengths and cultivating them in a way that allowed me to be authentic. I knew I was worthy of a healthy work environment and dared to stand up for that right, which ultimately helped to stabilize an organization and create a safer space for myself and my colleagues.

These days I don't stress over presenting myself as the "perfect candidate" for a role within an organization. Confident in my experience as a fundraiser, I focus on

making sure I'm inspired by the mission, invested in the fundraising projects, and perhaps most importantly, interested in working with a manager and a team based on that gut instinct of whether or not I can trust them.

Key Takeaways:

Sometimes the quietest voice in the room can be the most influential. Personal power comes from not only how you act but how you react to others. You have the option to choose how you nurture relationships and build trust by showing up authentically, logically, and empathetically.

DISCLOSURE: Names have been changed to protect the identities of those involved.

Sarah Warner

Sarah Warner is a fundraising professional with more than twenty-five years of experience. She has primarily focused on campaigns for arts and education at premier organizations, including the Woodruff Arts Center, San Francisco Ballet, Stanford University, and The Tech Interactive. She is experienced in cultivating philanthropic relationships with high-profile executives/high-net-worth individuals, mentoring staff, motivating volunteers, organizing special events, and spearheading giving efforts from corporations, foundations, and individuals. She holds a B .S. in Human & Organizational Development from Vanderbilt University. She currently lives in Napa Valley where she is prioritizing health and wellness along with making

time to travel and photograph her adventures abroad as well as excursions closer to home.

https://www.linkedin.com/in/sarah-warner-1335296

11
The Gift of Margin

Jenny Remington

The last project I worked on before everything changed was leading a workshop called "Permission to Pause," where I taught executives and professionals how to slow down and get their needs met. I didn't know then that my life would grind to a halt just a few days later and I would have to use every bit of my resilience, self-care, and self-awareness to navigate my way through it.

Forty-four-year-old women aren't supposed to get concussions, and they certainly aren't supposed to demonstrate how to do it to a boat full of teenagers, but on a sunny Sunday morning, I showed how not to dismount a

wake surfboard and began the biggest healing journey of my life.

On this fateful weekend, we decided my two kids and my best friend's two kids would learn to wake surf, and I would teach them. I had learned to wake surf just a few months before and enjoyed the combination of strength, balance, and proximity to the boat when wake surfing. It felt really safe.

Before I jumped in the water, I stood on the back platform of the boat and demonstrated how to wake surf. The teens had all tried wakeboarding—where the board is strapped to your feet, and the boat travels at much faster speeds—so the biggest difference they needed to understand was how to keep the board under them. I explained where to place their feet on the board and how to shift their balance to allow the boat to pull them up.

It was a bright morning, so I kept my sunglasses on, something I had never done before. I jumped in the water with my board, feeling my snug life vest buoy me as I hit the water, and my son tossed me the rope. We practically had the lake to ourselves. I gave the thumbs up to my husband behind the wheel, and he yelled, "Here we go!" in response.

With my best friend filming on her iPhone, I pulled up easily and talked them through what I was doing: knees slightly bent, chest over hips, shoulders down, let the boat pull you, don't fight the waves. I felt proud of my strength and balance and hoped the kids would love this sport, too. It was exhilarating to have all eyes on me, not something this mom experiences very often.

After a few minutes, I decided that it was time to give someone else a turn. I hopped off the board and let go of the rope.

A split second later, the board crashed into my forehead, crushing my sunglasses into my orbital bone so hard that it whipped me away from the boat. I was dazed and put my hand to my eye, holding my broken sunglasses across my face.

Time slowed down.

I couldn't see our boat, and no other boats were in my line of sight. I didn't know what had happened, but I knew I was hurt. Believing I was suddenly all alone on the lake, I panicked. I began screaming in a voice that didn't sound like mine, holding my bleeding head and bobbing in the wake. Seconds felt like hours.

Everyone on the boat saw me fall, but that is normal: Every ride behind a boat ends with the person in the water. As they got closer, they heard my primal screaming and knew something was very wrong. My friend pulled on a life jacket and dove into the water to help me.

When he got to me, I kept screaming. Over my screams, he yelled, "We need an ambulance!" He put his arm across my chest to swim me back to the boat. I watched my legs try to kick. I heard the adults shouting about the closest hospital and speculating if we could get a medical helicopter to meet us at a nearby park. I heard the kids yelling that they couldn't find the first aid kit. I heard myself screaming loudest of all.

Even though I saw the boat, even though someone was swimming me back to safety, and even though I wanted to stop, I couldn't stop screaming for help. One of my greatest regrets about that day is that my children had to see me in that state: bleeding, terrified, unable to swim, unable to climb in the boat, and unable to stop screaming.

Once in the boat, I saw the blood on my hands and my terrified children's faces. Someone wrapped me in a towel, and someone else gave me a towel for my head. I slumped

down on the white leather bench, now covered in my blood, and finally, *finally* fell silent.

They took turns talking to me and urging me not to sleep. I tried to say to my oldest, "I'm okay." but the voice didn't sound like mine, and neither of us was convinced. I was too scared to say anything else, unsure what we'd both hear.

When our boat came rushing into our cove, our neighbors knew something was wrong by how fast we were traveling in the no-wake zone. They met us down on the dock where the husband, an EMT, did a quick assessment of my gash and looked into my eyes while the wife, chief of nursing for the local hospital system, was already on the phone to her hospital's ER.

They decided there wasn't time for me to change out of my wet, blood-soaked bathing suit. The men loaded me into the front seat of our truck, and the women hugged the now audibly sobbing kids. While my husband got his phone and keys, I hugged my kids and repeated, "It's okay. I'm okay," with my teeth chattering. It was torture to want to reassure them and know that I needed reassurance myself. I didn't know I would be okay.

The drive to the hospital was the first time it was quiet since we climbed in the boat hours before. My husband

drove fast on the country roads while I shivered and tried to stay calm. When I finally spoke, my voice was hoarse and slow: "I'm so mad that I couldn't stop screaming. I scared the kids."

At the ER, they sat me in a wheelchair and brought me to a room where I could change out of my cold, wet, blood-soaked bathing suit and into a dry hospital gown. When the nurse laid two warm blankets across me, finally feeling warm and safe, I felt my entire body relax.

The nurse cleaned the dried blood off my face and asked questions about the accident. I felt sluggish and weak like I was moving through syrup. I knew the answers to the questions, but I couldn't get to them fast enough. I kept looking at my husband for reassurance and help answering the questions.

A CT scan confirmed I did not have a brain bleed. Unfortunately, they didn't tell me that I had a concussion. I would learn that the hard way five long days later. They told me to take it easy, and my discharge paperwork instructed us on wound care.

The next day, I was sore and had a headache, but otherwise felt "normal." My primary focus was the large cut that I assumed would become an ugly scar across my forehead.

It looked like an angry eyebrow on a Disney villain. I never considered myself a vain person, but this change in my face upset me.

The following day, the first significant symptoms of my concussion showed up: I was sitting on a video call for a class I was attending, and I slid down in my chair, the way teenagers might do in class. I didn't notice myself sliding down, but when I saw myself in the video grid on the screen, I realized I didn't know how to sit back up. I stayed slumped down with panic building. I knew something was wrong but couldn't do anything about it: My brain felt so slow. At some point, I slid to the floor, carefully went to my bedroom from my home office, and laid down on my bed and cried, which brought on the first of many migraines.

That night, I had the first of many visceral nightmares. In this dream, I relived the accident: The water on my skin, my voice screaming for help, and watching my legs trying to kick while I was being pulled back to the boat. Over the next few months, my nightmares would take me back to other traumatic and painful memories from my life, not just the accident. I began to be afraid to sleep—not wanting to relive my worst days again and again.

Five days after the accident, I finally was able to meet with my primary care doctor. She had the notes from the ER, and I told her what I could about the accident. I told her about my nightmares, about how quick to anger and cry I had been since the accident, about the headaches, and how confused I have been, and that sometimes I couldn't find the words for what I wanted to say.

My doctor said, "That's because you have a concussion, a traumatic brain injury."

"No, the ER doctor told me I don't have a brain bleed," I protested.

She looked me in the eyes and said, "Yes, that's right. You don't have a brain bleed—which is good news—but you do have a concussion."

With her words, I felt my shoulders sag and my body release. I had been in a state of diligently fighting to be normal, and this word—concussion—was the permission I needed to not be okay.

After a moment I said, "I drove myself here."

"How did that go?" she asked.

"It was really hard and scary," I admitted.

Instructions on how to heal from a concussion are woefully inadequate: rest, avoid screens, and don't do too much mental work. I had this deep feeling that I knew how to help myself recover.

Over the past ten years in my coaching business, I've been teaching people to look at their lives—where they are overburdened and under-resourced—and consider what would nurture them through that stress with self-compassion. I help people grow their careers and thrive in their personal lives.

Friends encouraged me, "You are the self-care coach. You know how to take care of yourself. Now you have to practice what you preach." It was terrifying to feel as if I didn't have full access to all of my thoughts, and my emotions came on like a surprise storm. Somehow, from deep inside me I knew if I was going to recover, it would take everything I had put into place for my self-care practices, and I would need to give myself a lot of margin for healing.

So, I gave myself permission to pause and heal.

I knew how to listen to myself and respond to my needs. I had been practicing how to express and hold boundaries for years. I had spent years learning to let go of my people-pleasing tendencies. I learned how brave it is to be

vulnerable and to ask for what I need. I had spent the last ten years treating myself with grace and giving myself space. I knew I could support myself through this process of healing because the lessons that I learned throughout my life are guideposts in how I coach people on how to take care of themselves. With all my focus on my own healing: I could support myself back to wellness.

Recovery included lots of hard days, night terrors, unpredictable emotional spikes, and lots of revisiting past unresolved trauma. I gave myself space and avoided over-stimulation, realizing through my journaling that I needed to put some boundaries around myself to protect me in my delicate state. I worked with a spiritual guide trained in mindfulness and trauma recovery to process the painful memories that surfaced. I practiced holding boundaries with people who added stress to my fragile psyche. I had one visitor max a day and always took a nap afterward. I ate brain-healthy foods high in Omega-3s, like berries, organic fish, and walnuts.

I sat on the porch most days, listening to my wind chimes and watching the trees in the wind. I listened to the same two songs over and over. They each became meditations for me and helped me pass the time when I couldn't sleep or when I was afraid to sleep. I kept a journal where I

allowed myself to express my fears and track my symptoms. I forgave myself for the unpredictability of my emotions.

The path to recovery from a concussion and trauma is not straightforward, but I did my best each day to choose the path of self-healing. In the margins of my healing, the lessons I had been working on throughout my adult life served me not only in recovering but also in becoming more resilient, more authentic, and more committed than ever to my well-being.

As I reflect back, one of my first lessons in navigating stress came when I was twenty weeks pregnant with my first child. I had a panic attack while in a yoga class, of all places. While all the other mothers-to-be were moving through their sun salutation, I was still sitting in the first posture, with my face screwed up tight, hands gripping my thighs, and tears streaming down my cheeks. I hadn't noticed that she'd given instructions to the class—my mind was six miles north at my high-tech corporate job, where I was on the committee to manage communications for the company's voluntary layoff planned for the following month. I was thinking about the executive talking points and how we would "spin" this news to employees right before the holidays. My heart was racing, and I was feeling a heaviness in my chest and cramping in my belly. The

teacher approached me and gently put her hand on my knee.

She said, "Hi Jenny. Where are we? Is everything okay?"

My eyes popped open and met her concerned gaze. "No," I said. "I'm overwhelmed and don't know what to do."

With tears flowing and panting from the weight of stress, I spent the rest of the class in child's pose. Knowing I needed the support, she stayed by my side and led the rest of the class with only her verbal instructions. She kept her hands on me, whispering and guiding me to reconnect with my body and inviting me to focus on my breath.

The next day, I put my name on the list for the voluntary layoff. I felt I had no choice. I was afraid that the physical and psychological stress and overwhelm would harm my baby and make me a terrible mother right from the start.

Looking back, I can now see that I had created a toxic blend of over-functioning, people-pleasing, and boundary-free working and living. I was operating at my full capacity every day. I didn't know any other way to do it.

Operating in this way was taking a toll on me in ways I was ashamed to admit. I didn't want to be a person who was overwhelmed or stressed out. I had heard the mantras

about not complaining about being busy. And be grateful. *Always grateful*. I had a great career and a healthy body, I was building a family with the person I loved, and I live with privileges many people do not have. Of course, I had heard of "self-care," but I regarded it the way I look at cats: *You are cute, but I'm allergic*.

I didn't realize that the load I was carrying—my responsibilities, stressors, and unrealistic expectations—was pushing me to a breaking point. My perfectionism, people-pleasing and over-functioning had eroded my idea of myself and my well-being.

The only solution I could see was to quit my job.

I see this so often in my coaching business: Highly capable women feel as if they are drowning in the weight of their jobs and their responsibilities. They fantasize about running away and not looking back. It isn't that they don't know how to manage their time or delegate—although they receive plenty of messages that they should be better at that, too. The real problem is that they are operating at full capacity and doing all...the...things. In doing so, they have lost themselves along the way.

I know this because I lost myself along the way, too. And in the process of finding my way back to myself, I discovered

my gift for coaching people to find their authentic selves again.

My lack of margin hit me again three years later when I had two small kids. My three-year-old was having behavior problems that we couldn't seem to get a handle on. In our sleep-deprived desperation, we went to see a child psychologist, just sure that there was something to "fix." She said that it sounded like he was going through separation anxiety and gave some specific suggestions on how to help.

I thought, *That was easy! Ten minutes with an expert, and we have our solution!*

And then, she said words that changed my life: "Now, let's talk about Momma."

All of a sudden, I felt the heat in my cheeks as if I were under the lights in an interrogation room. "What do you mean?" I said, in a voice that was quieter and higher-pitched than my own.

She asked me, with kindness that came through her eyes—locked with mine—and her words: "What are you doing to take care of yourself?"

I was dumbfounded. I thought, *What on earth is she asking? We are here for our child. What does that have to do with anything?*

When it was clear that she was patiently waiting for me to answer her, I told her, "Nothing. There is no time. I am stretched so thin, and everyone wants a piece of me."

I didn't say what I know now: *I'm a martyr and don't ask for help. I'm a perfectionist committed to the idea that I will help everyone, but I won't allow that vulnerability in me. I don't have boundaries. I don't show myself any compassion or empathy. And, I don't really know who I am, separate from all my responsibilities.*

I had been working so hard to care for everyone else that I had run myself ragged; I was threadbare and struggling. Despite my best efforts to hold them back, big tears welled up in my eyes and rolled down my cheeks. With tremendous vulnerability, I told the counselor that I felt like I was to blame for all the family's problems, and this was another thing I wasn't doing "good enough." I flushed with shame and frustration, feeling like everything was all my fault. Only this time, I couldn't quit.

I cried big tears of sadness and grief that I had "let myself" get to this place. Hadn't I read about how good mothers take care of themselves?

Wading through my shame and overwhelm, she gently guided me back to our conversation. She asked, "What do you want most for your kids?"

I said, "I want them to grow up happy and healthy."

"Okay, and what if I could promise you that the best way to ensure that they grow up happy and healthy is for you, their momma, to be happy, healthy, and most wonderfully, authentically, YOU?"

After a beat, I responded, "If you promise that, I'll do whatever you tell me to do."

She said, "Good! You'll need to start making space for yourself." Later, I learned this is called boundaries.

And she said, "You'll need to give yourself some grace." Later, I would call this self-compassion.

And finally, "You'll need to do things that make you feel alive and find your way back to yourself." Later, I would learn to call this self-care.

Her prescription for me felt revolutionary: Make space for myself, and everyone benefits. Practice holistic self-care, and I will find my humanity again. Later, I would name this intentional space in my life margin.

This forty-five-minute conversation triggered something in me that led me to where I am today. I began discovering a more authentic way to be in the world. I was taking care of myself and in the process I was becoming more resilient.

I picked up yoga again. I signed up for a writing class. I started prioritizing seeing my girlfriends again. Family life was still hard, but I was also getting breaks and finding joy in being myself, separate from motherhood. Before long, I started dreaming about what I wanted to do with my life, and I discovered my calling: to coach women out of overwhelm and to live a life they love.

This shift from constantly overworking to making space for myself profoundly and positively impacted how I connect with everyone around me. In the margin, I found the energy and courage to start my own coaching business, one of the most rewarding decisions of my life. I finally believed—without a doubt—that when I take care of myself, I am an excellent coach, partner, friend, citizen, and mother.

But even with all the gifts I have acquired, life continues to happen. With each chapter of life, I'd need to learn new ways to support myself with boundaries, self-compassion and creating margin. When my dad was diagnosed with Glioblastoma, a terminal brain cancer, I was challenged to use every part of my resilience and find new, deeper ways to support myself through the biggest crisis my family had ever faced. Living three hours away, I made the journey as often as possible to help my family navigate this new reality and spend as much quality time as I could with my dad.

This was, by far, the most challenging season of my life, and I leaned heavily into the practices I had put in place after our meeting with the child psychologist. I was already intentional about my energy and my time. I had (mostly) let go of my perfectionist tendency to fill up every minute helping other people, and I put a few things on my calendar that filled up my cup and gave me joy.

In between visits and calls with my parents, I took care of myself and my family. I met friends for outdoor yoga every full moon. I took mindfulness classes. I set aside time to write. I prioritized a few things at home (quality time with my husband and kids) and let less-essentials go (piano lessons and class parties). I prioritized my 1:1 client work

and paused an ambitious speaking project. I moved my body, was mindful of my eating, and slept regularly.

In small ways and significant ways, I carved out space in my calendar, home, and heart that was essential for me to survive that season. While the eighteen months we had with my dad after his diagnosis were incredibly difficult, I came out the other side grateful for my life, thankful for our time with him, and more resilient.

A few months after my dad's passing, I led several small group coaching cohorts. The groups helped women develop self-awareness of their needs and practice holistic self-care. I noticed a pattern: As much as each person was competent and highly motivated about their personal growth, the reality was that they were over-committed, overburdened, and under-nourished.

There was a real or imagined perception that there was no space for themselves. They each felt they had to keep plowing forward, even though it was draining them. They had big jobs, big expectations, and felt overwhelmed.

I said, "It sounds like you don't feel like you have any margin in your life."

They were silent.

Someone said, "What do you mean, *margin*?"

I realized I had never said this word in a coaching session before. As business owners and professionals, they probably had a very different idea of what "margin" I was speaking about.

I said, "Margin is the space in our lives that we intentionally leave blank. Open. Available. Peaceful."

Someone nodded.

I kept going: "Margin is the space between what we carry—our stress, responsibilities, and LIFE in general—and our capacity. Margin is the space you give yourself to recover and be yourself."

The recognition in their eyes, the nodding heads, and their tears told me I had touched on a profound truth, and the word "margin" spoke to them in a way that "self-care" might not have.

Through all of this, I have learned that the conventional strategies for building a business or advancing a career typically differ wildly from creating a fulfilling life.

In my coaching business, I see people who have hit certain milestones of success only to be on the verge of a

breakdown and burnout. People often come to coaching in a state of overwhelm or stress. They are often highly capable, and feel like something is wrong, even if they have done everything "right." They feel like they have lost themselves and squeezed out every bit of space in their calendar, brains, and hearts. They are high-achievers who can't keep up with the demands of their life, work, and expectations. I empathize with them because I have been there, too.

And this is where the common pressures of our contemporary working society are counter to what truly will enable us to thrive. We don't need to do more and be more of what the world demands. Too many people suffer from overwhelm and burnout, following the "do more, more...*MORE!*" mentality. It is only when we make space for our humanity—alongside building a meaningful career—that we can truly thrive.

It wasn't until the trauma of my concussion accident that I realized the essential lessons of creating a margin in my life over the past decade allowed for my full humanity and, ultimately, my recovery. The choices I made every day in the years leading up to my accident to give myself grace and space with healthy, self-supporting habits would be-

come instrumental in my healing journey. That's the gift of margin.

Key Takeaway:

Margin is the space we build into our lives and our careers to allow our full humanity. Margin helps us to avoid burnout, cope with stress and ensure that we navigate our careers without losing ourselves. The path to becoming your most resilient, authentic, and healthy version of yourself is to create margin.

Jenny Remington

Jenny Remington is an ICF-certified coach who has empowered hundreds of professionals, entrepreneurs and parents to reignite their career, discover their path or realign their life. Jenny's mission is to boost happiness, create strong visions, nurture inner strength and to live mindfully with holistic self-care practices. Jenny has a gift for bridging the personal with the professional, helping clients improve all aspects of their life. Her background in communications for global tech companies, nonprofits and PR agencies help her empower her clients to think beyond the role they have today. Jenny lives in Austin with her husband of nineteen years, two teens and the wild-card of the family is Gus, the schnoodle. When she's not coaching, Jenny loves to practice yoga, read, write, to bring

people together, stand up paddleboarding, and engage in deep conversations with people she loves.

www.jennyremington.com

https://www.linkedin.com/in/jennyremington/

https://www.instagram.com/coachjennyrem/?hl=en

CHILDREN'S EMERGENCY SHELTER

All proceeds from this multi-author book are donated to Central Texas Table of Grace.

Central Texas Table of Grace is a 501(c)(3) non-profit organization that exists to provide emergency shelter services to the foster children and administers our Grace365 Supervised Independent Living program for young adults aging out of foster care. Their support contributes to an improved quality of life for youth and their families. The organization's projects, implemented by an experienced staff, emphasize creating a caring climate for youth. Supporting the development of self-confidence, healthful living, and good judgment, Central Texas Table of Grace provides our children with a thorough foundation for success.

Follow us on social media to find out more.

https://www.facebook.com/centraltexastableofgrace

https://www.instagram.com/ctxtableofgrace/

https://www.linkedin.com/company/central-texas-table
-of-grace/

https://twitter.com/CTXTableOfGrace

https://www.tiktok.com/@ctxtableofgrace

About Sulit Press

Sulit Press is a boutique publishing house that provides high-touch support to thought leaders, industry shakers, and changemakers writing impactful nonfiction books. Whether you're interested in publishing your **personal memoir** or industry-specific **solo books,** or joining high-vibe, collaborative **multi-author books**, we'll help you transition from *aspiring* author to *published* author!

Founder and CEO Michelle Savage is an international best-selling author, speaker, book coach, and publisher. As the founder of Sulit Press, Michelle helps busy execs, entrepreneurs, coaches, writers, storytellers, and other go-getters make the leap from aspiring authors to published authors in half the time it takes to go it alone. She

believes everyone has a story worth telling and teaches the craft of telling it well by providing personalized, hands-on, heart-centered support to every author.

Learn more at https://www.sulitpress.com/

Made in the USA
Coppell, TX
31 May 2024